ARCHAEOLOGIST'S TOOLKIT

SERIES EDITORS: LARRY J. ZIMMERMAN AND WILLIAM GREEN

The Archaeologist's Toolkit is an integrated set of seven volumes designed to teach novice archaeologists and students the basics of doing archaeological fieldwork, analysis, and presentation. Students are led through the process of designing a study, doing survey work, excavating, properly working with artifacts and biological remains, curating their materials, and presenting findings to various audiences. The volumes—written by experienced field archaeologists—are full of practical advice, tips, case studies, and illustrations to help the reader. All of this is done with careful attention to promoting a conservation ethic and an understanding of the legal and practical environment of contemporary American cultural resource laws and regulations. The Toolkit is an essential resource for anyone working in the field and ideal for training archaeology students in classrooms and field schools.

Volume 1: *Archaeology by Design* CC83 .B58 2003
By Stephen L. Black and Kevin Jolly

Volume 2: *Archaeological Survey* CC76.3 .C65 2003
By James M. Collins and Brian Leigh Molyneaux

Volume 3: *Excavation*
By David L. Carmichael and Robert Lafferty CC76 .C37 2003

Volume 4: *Artifacts* CC75.7 .E97 2003
By Charles R. Ewen

Volume 5: *Archaeobiology* CC75.7 .S59 2003
By Kristin D. Sobolik

Volume 6: *Curating Archaeological Collections:*
** *From the Field to the Repository*** CC55 .S85 2003
By Lynne P. Sullivan and S. Terry Childs

Volume 7: *Presenting the Past* CC75.7 .Z56 2003
By Larry J. Zimmerman

ARCHAEOLOGIST'S TOOLKIT

SERIES EDITORS: LARRY J. ZIMMERMAN AND WILLIAM GREEN

The Archaeologist's Toolkit is an integrated set of seven volumes designed to teach novice archaeologists and students the basics of doing archaeological fieldwork, analysis, and presentation. Students are led through the process of designing a study, doing survey work, excavating, properly working with artifacts and biological remains, curating their materials, and presenting findings to various audiences. The volumes—written by experienced field archaeologists— are full of practical advice, tips, case studies, and illustrations to help the reader. All of this is done with careful attention to promoting a conservation ethic and an understanding of the legal and practical environment of contemporary American cultural resource laws and regulations. The Toolkit is an essential resource for anyone working in the field and ideal for training archaeology students in classrooms and field schools.

Volume 1: *Archaeology by Design*
By Stephen L. Black and Kevin Jolly

Volume 2: *Archaeological Survey*
By James M. Collins and Brian Leigh Molyneaux

Volume 3: *Excavation*
By David L. Carmichael and Robert Lafferty

Volume 4: *Artifacts*
By Charles R. Ewen

Volume 5: *Archaeobiology*
By Kristin D. Sobolik

**Volume 6: *Curating Archaeological Collections:
From the Field to the Repository***
By Lynne P. Sullivan and S. Terry Childs

Volume 7: *Presenting the Past*
By Larry J. Zimmerman

CURATING ARCHAEOLOGICAL COLLECTIONS

FROM THE FIELD TO THE REPOSITORY

LYNNE P. SULLIVAN
S. TERRY CHILDS

ARCHAEOLOGIST'S TOOLKIT
VOLUME 6

ALTAMIRA
PRESS

A Division of Rowman & Littlefield Publishers, Inc.
Walnut Creek • Lanham • New York • Oxford

AltaMira Press
A Division of Rowman & Littlefield Publishers, Inc.
1630 North Main Street, #367
Walnut Creek, CA 94596
www.altamirapress.com

Rowman & Littlefield Publishers, Inc.
4501 Forbes Boulevard, Suite 200
Lanham, MD 20706

PO Box 317
Oxford
OX2 9RU, UK

British Library Cataloguing in Publication Information Available

Library of Congress Cataloging-in-Publication Data

Sullivan, Lynne P.
 Curating archaeological collections : from the field to the repository / Lynne P.
Sullivan and S. Terry Childs.
 p. cm.— (Archaeologist's toolkit)
 ISBN 0-7591-0402-6 (cloth : alk. paper) — ISBN 0-7591-0024-1 (pbk. : alk. paper)
1. Archaeological museums and collections. 2. Archaeological museums and
 collections—Management. 3. Antiquities—Collection and preservation. 4.
Museum technique. I. Childs, S. Terry. II. Title. III. Series.

 CC55 .S85 2003
 930.1'074'73—dc21
 2002015057

Printed in the United States of America

∞™ The paper used in this publication meets the minimum requirements of
American National Standard for Information Sciences—Permanence of Paper
for Printed Library Materials, ANSI/NISO Z39.48–1992.

CONTENTS

Series Editors' Foreword vii

Acknowledgments xi

1 Introduction 1

**2 A Brief History of Archaeological Curation in the
United States** 5
*The Museum Era of Archaeology: Nineteenth
Century to the 1930s • Early Federal Archaeology
Programs: 1930s and 1940s • The Postwar Construction
Boom and the "New Archaeology": 1945 to 1970 •
Making versus Caring for Collections: The 1970s and
Beyond • Conclusion*

3 The Current Status of Archaeological Collections 23
*Federal Legislation and Policy • Key Elements of the
Curation Crisis • The Bright Side*

4 Repositories: What Are They, and What Do They Do? 45
*Kinds of Repositories • What a Repository Does and
Why • Responsibilities and Training of Repository
Staff • Conclusion*

5 Managing Curated Collections: The Basics 59
*Acquisitions Policies and Practices • Accessioning •
Cataloging • Collections Preparation: Labeling and*

*Conservation • Storage • Inventory Control and Data
Management • Deaccessioning • Public Access and
Use • Conclusion*

**6 Making a Collection: Fieldwork Practices and
 Curation Considerations 79**
 *Before the Field: Project Design • In the Field:
 Sampling and Conservation • In the Laboratory:
 Applying the Sampling Strategy and More
 Conservation • In Your Office after the Field
 Project: Records Management • Conclusion*

7 Working with a Repository 91
 *Arranging for Long-term Curation • Using Curated
 Collections • Conclusion*

8 The Future of Archaeological Collections Curation 103
 *Access: Collections in the Computer Age • Use of
 Curated Collections • The "Big Picture": Curated
 Collections as Samples of the Archaeological Record •
 Encouraging Repositories to Curate Representative
 Samples of the Archaeological Record • Coordinated
 Regional Planning • Support for Curating
 Archaeological Collections • Is It All Worth It?*

Appendix: Useful Internet Sites Related to Curating
 Archaeological Collections 121

References 127

Index 141

About the Authors and Series Editors 147

 # SERIES EDITORS' FOREWORD

The Archaeologist's Toolkit is a series of books on how to plan, design, carry out, and use the results of archaeological research. The series contains seven books written by acknowledged experts in their fields. Each book is a self-contained treatment of an important element of modern archaeology. Therefore, each book can stand alone as a reference work for archaeologists in public agencies, private firms, and museums, as well as a textbook and guidebook for classrooms and field settings. The books function even better as a set, because they are integrated through cross-references and complementary subject matter.

Archaeology is a rapidly growing field, one that is no longer the exclusive province of academia. Today, archaeology is a part of daily life in both the public and private sectors. Thousands of archaeologists apply their knowledge and skills every day to understand the human past. Recent explosive growth in archaeology has heightened the need for clear and succinct guidance on professional practice. Therefore, this series supplies ready reference to the latest information on methods and techniques—the tools of the trade that serve as handy guides for longtime practitioners and essential resources for archaeologists in training.

Archaeologists help solve modern problems: They find, assess, recover, preserve, and interpret the evidence of the human past in light of public interest and in the face of multiple land use and development interests. Most of North American archaeology is devoted to cultural resource management (CRM), so the Archaeologist's Toolkit focuses on practical approaches to solving real

problems in CRM and public archaeology. The books contain numerous case studies from all parts of the continent, illustrating the range and diversity of applications. The series emphasizes the importance of such realistic considerations as budgeting, scheduling, and team coordination. In addition, accountability to the public as well as to the profession is a common theme throughout the series.

Volume 1, *Archaeology by Design*, stresses the importance of research design in all phases and at all scales of archaeology. It shows how and why you should develop, apply, and refine research designs. Whether you are surveying quarter-acre cell tower sites or excavating stratified villages with millions of artifacts, your work will be more productive, efficient, and useful if you pay close and continuous attention to your research design.

Volume 2, *Archaeological Survey*, recognizes that most fieldwork in North America is devoted to survey: finding and evaluating archaeological resources. It covers prefield and field strategies to help you maximize the effectiveness and efficiency of archaeological survey. It shows how to choose appropriate strategies and methods ranging from landowner negotiations, surface reconnaissance, and shovel testing to geophysical survey, aerial photography, and report writing.

Volume 3, *Excavation*, covers the fundamentals of dirt archaeology in diverse settings, while emphasizing the importance of ethics during the controlled recovery—and destruction—of the archaeological record. This book shows how to select and apply excavation methods appropriate to specific needs and circumstances and how to maximize useful results while minimizing loss of data.

Volume 4, *Artifacts*, provides students as well as experienced archaeologists with useful guidance on preparing and analyzing artifacts. Both prehistoric and historic-era artifacts are covered in detail. The discussion and case studies range from processing and cataloging through classification, data manipulation, and specialized analyses of a wide range of artifact forms.

Volume 5, *Archaeobiology*, covers the analysis and interpretation of biological remains from archaeological sites. The book shows how to recover, sample, analyze, and interpret the plant and animal remains most frequently excavated from archaeological sites in North America. Case studies from CRM and other archaeological research illustrate strategies for effective and meaningful use of biological data.

Volume 6, *Curating Archaeological Collections*, addresses a crucial but often ignored aspect of archaeology: proper care of the specimens

and records generated in the field and the lab. This book covers strategies for effective short- and long-term collections management. Case studies illustrate the do's and don'ts that you need to know in order to make the best use of existing collections and to make your own work useful for others.

Volume 7, *Presenting the Past*, covers another area that has not received sufficient attention: communication of archaeology to a variety of audiences. Different tools are needed to present archaeology to other archaeologists, to sponsoring agencies, and to the interested public. This book shows how to choose the approaches and methods to take when presenting technical and nontechnical information through various means to various audiences.

Each of these books and the series as a whole are designed to be equally useful to practicing archaeologists and to archaeology students. Practicing archaeologists in CRM firms, agencies, academia, and museums will find the books useful as reference tools and as brush-up guides on current concerns and approaches. Instructors and students in field schools, lab classes, and short courses of various types will find the series valuable because of each book's practical orientation to problem solving.

As the series editors, we have enjoyed bringing these books together and working with the authors. We thank all of the authors—Steve Black, Dave Carmichael, Terry Childs, Jim Collins, Charlie Ewen, Kevin Jolly, Robert Lafferty, Brian Molyneaux, Kris Sobolik, and Lynne Sullivan—for their hard work and patience. We also offer sincere thanks to Mitch Allen of AltaMira Press and a special acknowledgment to Brian Fagan.

LARRY J. ZIMMERMAN
WILLIAM GREEN

ACKNOWLEDGMENTS

No book is solely the product of its authors, and this one is no exception. We can't possibly thank everyone individually, but we wish to recognize several persons for their help and for their tolerance of this project. First, we thank Bill Green and Larry Zimmerman for inviting us to participate in the Toolkit series. We appreciate Bill's patient editorial work that helped make our manuscript more readable. We also thank Mitch Allen at AltaMira Press for his comments and for keeping the series on track, and we thank the members of the production staff at AltaMira Press for turning our computer files and stacks of paper into an actual book.

Several people read sections of our draft manuscript and provided useful information and helpful suggestions, including Harriet Beaubien, Cindy Stankowski, and Eileen Corcoran. Discussions at the National Archaeological Collections Management Conference in San Diego and with members of the Society for American Archaeology's new Committee on Curation also provided needed feedback on ideas as well as confirmed the widespread nature of curatorial problems and the many permutations.

Jeff Chapman and the staff of the McClung Museum patiently tolerated Lynne's time spent on the manuscript in the midst of developing major new exhibits on Tennessee archaeology. Lindsay Kromer, photographer at the McClung Museum, provided us with the photos, and Jennifer Barber, graduate assistant, helped with proofreading. Terry attributes her extensive exposure to and involvement with federal curation to the guiding interest of Frank McManamon and

Veletta Canouts in the National Park Service's Archeology and Ethnography Program, where she works by day.

We also thank our many teachers of the value of curation and curated collections—including some archaeologists we never personally met who kept meticulous records and well-organized materials. We also learned from those at the other end of the spectrum, but we prefer to thank those who provided the positive experiences!

Our colleagues fully in the museum world also deserve thanks for putting up with the somewhat warped perspectives of two archaeologists who know enough about collections care (especially conservation) to be dangerous.

Last but not least, we thank *you*, the reader, for wanting to learn about archaeological curation. The more people who care enough to learn about this topic, the more likely it is that archaeological collections will receive the care they need to be useful to future generations.

1

INTRODUCTION

Many archaeologists believe curation is something that happens only *after* fieldwork. This notion, along with a related set of historical circumstances, has contributed to a crisis in curation of archaeological collections. We hope to show that curation is a *process* that begins in the field and continues in the repository. As such, curation is the responsibility of many individuals and institutions, from field archaeologists and their sponsors and employers, to collections managers and curators and the repositories that employ them.

The curation crisis did not happen overnight, nor will it quickly be resolved. One thing is for certain: The crisis will be perpetual unless there are coordination and shared goals among all the players to assure adequate care for archaeological collections. If this book helps archaeologists take steps in that direction, it will have served its purpose.

Archaeologists typically do not learn about curatorial issues and practices in school. Graduate programs rarely offer such classes, nor is discussion of curation usually a part of the material covered in the relatively few classes on cultural resource management. Even museum classes do not offer the kinds of information archaeologists need to deal with curation. These classes usually focus on exhibits, not on collections management concerns or collections issues in the field. This critical omission in basic archaeological training still is not fully recognized by the profession, even in the context of ongoing discussions of curricular reform (Bender and Smith 2000). In this book, we aim to help archaeologists understand the history behind the curation crisis, where we are today as a profession and the legal

aspects, and where we seem to be headed. We also consider basic technical information about making collections with curatorial considerations in mind, and the hows and whys of working with repositories to ensure adequate long-term curation. We summarize salient points and procedures in tables for easy reference, and we include case studies and examples to help readers relate our discussions to real-world situations.

Before discussing curation itself, we need to define the kinds of materials that comprise archaeological collections. Many archaeologists, museum professionals, and archivists tend to think of archaeological collections as artifacts and specimens—that is, the pottery sherds, animal bones, chert flakes, projectile points, and so forth that archaeologists collect in the field. These objects are only part of an archaeological collection. Artifacts and specimens are worthless for research or interpretation unless they are accompanied by documentation that records, often very precisely, where these things were found—that is, the provenience. The integration of these records with the objects and specimens is what separates a systematic archaeological collection from an antiquarian collection. *Archaeological* collections are made to collect and preserve information that is useful for research and interpretative purposes, while *antiquarian* collections are made solely for the intrinsic value of the artifacts. Thus, without the accompanying records, a collection of "old things" is just that; it is not an archaeological collection.

The records that form significant elements of archaeological collections include field notes, photographs, maps, and suites of forms (level, feature, photo log, etc.), as well as other paperwork and electronic data made to record and preserve contextual and analytical information. Other kinds of records also may be important components of archaeological collections. In today's world of cultural resource management projects, scopes of work, proposals, and limited-distribution reports often are the only documents that contain essential contextual information on where, how, and why fieldwork was done. So, in short, when we use the term *archaeological collections* in this book, we mean both the collected materials and the associated records.

Now that we've defined what we curate, we can define curation. What is archaeological curation, and why is it important? As noted earlier, we view curation as a process, one that is never ending and that requires constant vigilance. Archaeological curation is the process of managing and interpreting archaeological collections

over the long term. By *managing*, we mean making and caring for collections, and rendering them accessible for multiple purposes. By *long term*, we mean as long as the constituent materials of the objects and records can be preserved. *Interpretation* in a curatorial sense usually refers to using collections for public education. We only touch on this latter aspect of archaeological curation (see Toolkit, volume 7); our primary focus is on the managerial aspects of curation because that is where the most serious problems lie.

Regarding the importance of curation, we hope that the research significance of collections is self-evident, at least to archaeologists. Archaeological research relies on material objects and their archaeological contexts (i.e., proveniences), so the collections resulting from research become invaluable and irreplaceable. Quite simply, without collections we cannot do our work. They are as much our tools as trowels and shovels. Yet, from our collective behavior in regard to curation, one would think that we value our trowels and shovels much more than we do the collections! Furthermore, archaeological collections are important not only to archaeologists. Peoples whose cultural heritage is intimately intertwined with collections—often the only tangible evidence of their past—also care a great deal about these materials.

Another equally important aspect of curation is accountability. Many, if not most, archaeological collections are in public trust. When curatorial practices are poor or nonexistent, everyone loses: Archaeologists suffer loss of irreplaceable research data, the general public suffers loss of an expensive and valuable educational resource, and those whose heritage may be linked to the collections lose that part of themselves. As the makers of archaeological collections, archaeologists are among the persons and institutions accountable for ensuring proper care of these materials. Why should the public spend money to preserve information from archaeological resources if the basis of that information, the collections, are not preserved for the long term? The credibility of archaeologists, and indeed archaeology, quickly becomes called into question when collections are lost, mismanaged, or destroyed because the field archaeologist did not consider curation needs.

Before discussing the organization of this book, we need to clarify our use of the terms *repository* and *museum*. A repository simply is a place to care for collections. It does not necessarily have the public educational functions of a museum, such as exhibits and public programs. The heart of museums, on the other hand, traditionally has

been the collections and their care, yet these institutions also exist to educate the general public through displays and programming. Today, repositories that are museums, and those that are not, care for archaeological collections. We discuss the types of repositories in chapter 4, but suffice it to say here that our use of the term *museum* means an institution with collections and exhibits, while the term *repository* refers more broadly to a range of institutions that care for collections.

Because we are archaeologists ourselves, it is perhaps not surprising that the organization of this book proceeds from the past to the future. We begin in chapter 2 with a history lesson that shows how the making of collections gradually became separated from the care of collections. In that context, we provide a case study of a large collection, made in connection with a New Deal–era federal project, as an example of the kinds of materials that now are being curated, the kinds of issues and circumstances that surround their creation and care, and their research potential. Then we move to the present day, with an overview of the laws and regulations that pertain to collections and a consideration of the many pressing issues related to curation. The next three chapters provide basic technical information on curatorial practice, common procedures followed by repositories, and what archaeologists need to know to arrange effective agreements for long-term collections care. Chapter 6 outlines the kinds of curatorial concerns archaeologists and managers need to consider in designing and implementing field projects. Chapter 7 focuses on how to work with a repository both before a collection is made and once it is ready to be delivered after fieldwork and analysis. The final chapter discusses collections accessibility and use issues and the "big picture" in terms of what is being curated and the cost of doing so. An appendix provides a list of useful websites that deal with aspects of archaeological curation.

As more archaeologists become familiar with the background, procedures, and issues of curating archaeological collections, from the field to the repository, we will be able to move forward to resolve the current crisis. All archaeologists who make collections must help plan for the long-term care of those collections. The very hard lessons we've already learned in terms of loss of irreplaceable materials need to be communicated to students so that as younger generations enter the profession we don't repeat past mistakes. Learning from archaeology's own past and changing old attitudes and habits are critical challenges for curating archaeological collections.

2

 # A BRIEF HISTORY OF ARCHAEOLOGICAL CURATION IN THE UNITED STATES

A general trend in American archaeology seems to be increased separation between the making of archaeological collections (i.e., fieldwork) and the caring for archaeological collections (i.e., curation). In the nineteenth and early twentieth centuries, these activities more often were accomplished under the direction of single individuals or institutions. Now, multiple individuals and institutions often are involved in various stages of archaeological fieldwork, analysis, reporting, and curation.

A brief review of the history of archaeological curation in the United States is useful for understanding the current situation. As part of this review, we note some changes in archaeological collecting and collections, and we look in particular at one large collection as a case study of the history, contents, uses, and care of older but significant archaeological materials.

THE MUSEUM ERA OF ARCHAEOLOGY: NINETEENTH CENTURY TO THE 1930S

Museums are the oldest and perhaps most common kind of public repository for archaeological collections. The histories of museums and archaeology are closely intertwined. In fact, the beginnings of archaeological chronology are rooted in museology. In Denmark in 1819, J. C. Thomsen developed the "three-age" system (Stone, Bronze, and Iron) for European prehistory to organize the displays of the national museum. In 1873, Otis Mason used Lewis Henry Morgan's

now-antiquated model of social evolution with its stages of savagery, barbarism, and civilization to organize the collections at the Smithsonian Institution (Conn 1998; Willey and Sabloff 1977). This close association meant that making, caring for, and interpreting archaeological collections all were accomplished under one roof. By the end of that era, however, museums no longer were at the forefront of developments in archaeology, and the making of collections began to become separate from collections care. The early histories of museums and archaeology in the United States chronicle this process.

The nature of museums has changed through time. A few museums were created in the United States toward the end of the eighteenth century, including the Charleston Museum in South Carolina that opened in the 1770s and Peale's Museum in Philadelphia (1872). These early museums were "cabinets of curiosities," featuring shrunken heads, Egyptian mummies, two-headed beasts, and other items intended to entertain the public (Alexander et al. 1992). The antiquarians who collected archaeological objects at this time also typically saw them as curiosities. Methodical collection, study, and arrangement of objects, as well as subject specialization, including the differentiation between art and natural history museums, came about a century later. It was not until the second half of the nineteenth century that the concept of the public educational museum became established (Burcaw 1997; Conn 1998). This is also the same era when archaeology emerged as a formal professional discipline. The late nineteenth and early twentieth centuries have even been dubbed "the museum era" of American anthropology (Jonaitis 1992; Willey and Sabloff 1977).

The maintenance of elite European society was a major impetus for the establishment of public museums. The notion that museums should be places for public education was influenced by revolutions in Europe, which made aristocrats nervous enough to enact government-subsidized programs in an effort to raise the lot of the common people. Englishman James Smithson apparently saw a similar need in the United States and gave funds to establish a national public museum, the Smithsonian Institution, established by Congress in 1846 (Conn 1998).

The world's fairs of that era also were efforts by elites on both continents to "uplift" (and pacify) the "common people" and to teach the values and ideas of the ruling class. World's fairs of the late nineteenth century, in both Europe and the United States, often included anthropologically oriented exhibits that also boosted the growth of museums. In the United States, the 1876 Centennial Exposition in

Philadelphia helped the development of the American Museum of Natural History in New York City and the Smithsonian's National Museum of Natural History. Archaeological collections from North America became associated with such natural, rather than cultural, history museums for a reason: Prejudices and class structures often relegated studies and objects of minority groups to the natural world rather than to the world celebrated by the dominant Euro-American culture (Burcaw 1997; Conn 1998).

By the end of the nineteenth century, the United States had numerous well-established general and natural history museums, most of which were in the east. The rise of American museums was influenced by, but did not exactly mimic, European museums. Unlike many European countries, the United States did not organize a national museum with a regional structure. Americans also advanced a populist perspective that museums were places for public education, "public service," rather than strictly research. In fact, because the administration of the American Museum of Natural History embraced this attitude to the virtual exclusion of support for basic research, Franz Boas, the "father of anthropology," left his post there in the early 1900s for a faculty position at Columbia University. The pendulum on this issue continues to swing back and forth in many U.S. museums (Conn 1998; Jonaitis 1992). The emphasis away from research by museums undoubtedly helped foster the separation between archaeological collecting and curation.

Before this separation began, the making of archaeological collections changed from antiquarian fascination to systematic observation, recording, and collection. The emphasis on systematic recording by late nineteenth-century investigators resulted in the first significant holdings of curated archaeological, as opposed to antiquarian, collections in the United States (Willey and Sabloff 1977).

Both archaeology and museology were becoming professionalized as well. Archaeologists employed by museums did most of the early fieldwork in the United States, and the collections were curated by those institutions. Museums began to use the collections in public displays to interpret the research of their staffs, who were directly involved in making, curating, and interpreting the collections.

The most influential institutions in archaeology during the late nineteenth and early twentieth centuries were the Smithsonian Institution, the American Museum of Natural History, and the Peabody Museum of Archaeology and Ethnography at Harvard. The Museum of the American Indian, or Heye Foundation, in New York City also

was active during this period and amassed large collections. Its focus, however, was more on collecting than on the intellectual development of the discipline. Notables such as Cyrus Thomas, Frederick Ward Putnam, Arthur C. Parker, M. R. Harrington, William C. Mills, and Warren K. Moorehead built substantial archaeological collections in these and other institutions (Willey and Sabloff 1977).

From the mid–nineteenth century through the 1920s, the Bureau of American Ethnology (BAE) of the Smithsonian Institution employed many research associates in an active archaeological fieldwork program throughout the United States. The dominant question of the period concerned the origin of American Indians and resolution of the Moundbuilder Myth, which posited that a race of people other than the American Indians built the earthen mounds of the Americas. The BAE sponsored the first major archaeological survey of the period, resulting in E. G. Squier and E. H. Davis's *Ancient Monuments of the Mississippi Valley* (1848). Cyrus Thomas became director of mound exploration within the BAE in 1882. His publication in 1894 of the results of his extensive field investigations into the Moundbuilder issue settled, once and for all, the debate in favor of an American Indian origin. Subsequent work by William Henry Holmes and Aleš Hrdlička at the Smithsonian established that humans were a relatively recent addition to the New World, as compared with the Old (Willey and Sabloff 1977).

At the American Museum, Boas had worked to link archaeology and anthropology as early as 1899, and he set up a joint training program with Columbia University. He and other museum staff, including Nels C. Nelson, who also had worked for the Museum of Anthropology at the University of California, were instrumental in bringing stratigraphic excavation techniques from Europe to the Americas (Browman and Givens 1996).

Frederick Ward Putnam and his student Arthur C. Parker were influential museologists as well as museum archaeologists. Putnam was a leading figure of the period as an excavator, sponsor, administrator, and founder of museums and departments of anthropology, and he has been termed by Willey and Sabloff (1977:52) the "professionalizer of American archaeology." He became the curator of the Harvard Peabody Museum in 1874, bringing that institution to national attention. Putnam also helped found the Field Museum of Natural History in Chicago, the Anthropology Department at the University of California (Berkeley), and the Anthropology Department at the American Museum of Natural History. He trained a cadre of aspiring ar-

chaeologists, mainly through apprenticeships rather than formal academic methods, in the basics of careful fieldwork and recording.

Parker became the first salaried archaeologist hired by New York state. He worked for the State Museum from 1904 to 1924. He went on to become director of the Rochester (New York) Museum and, in 1935, the first president of the Society for American Archaeology. Like his mentor, Parker stressed professionalism. He changed the State Museum's policy for obtaining collections from purchasing archaeological specimens from collectors to financing professional excavations by museum staff. He also pioneered popular interpretation of archaeological research in museum exhibits (Sullivan 1992b).

The close connections between museums and archaeology also appear to have influenced the first federal law regarding protection and preservation of archaeological sites and collections. The Antiquities Act of 1906 (16 U.S.C. 431–33) stipulates that objects collected under the act are "for permanent preservation in public museums" and that "every collection made under the authority of the act and of these rules and regulations shall be preserved in the public museum designated by the permit and shall be accessible to the public." The act further specifies that if the designated public museum ceases to exist, the collections revert to the national "depository" (sic). Implicit in this law is the notion that arrangements for collections care will be made before a permit for fieldwork is granted. It was not until 1960 (see a later section) that mention is made again of where collections are to be curated (but without explicit mention of the kind of institution to be used), and it was not until 1979 that the law required making such arrangements prior to beginning fieldwork on federal land.

By the 1920s, archaeological research programs were established in many states, commonly as part of anthropology departments in universities. Museums became more concerned with direct public service. As universities trained aspiring archaeologists and museums turned toward increased public outreach, the heyday of museum-based research was over by the end of the 1920s. Some universities maintained museums with missions to educate the general public, but many universities did not maintain or develop museums. This shift of archaeology from museums to universities meant that the curation of archaeological collections was becoming removed from a museum context where they were used for research and to teach the lay public. Instead, collections were being placed in an academic context where they continued to be used for basic research, as well as for professional training of archaeologists. This change meant that

archaeological collections generally became less accessible to the general public. Perhaps public accountability for curation also became deemphasized as part of this change.

The use of archaeological collections as research tools rather than for exhibits is exemplified by the establishment of the Ceramic Repository for the Eastern United States at the Museum of Anthropology at the University of Michigan. The Ceramic Repository was organized in 1927 to develop and curate a collection of pottery sherds that would facilitate comparative knowledge of the distribution of artifacts in the eastern United States and to serve as a kind of "clearinghouse" for pottery studies. Carl E. Guthe, a Harvard graduate, was appointed director. Sherds submitted to the repository had to have detailed provenience information, and Guthe stressed that the emphasis of the repository was not on beautiful objects for museum displays but on research specimens (Lyon 1996).

Guthe continued in the museum field as director of the Rochester Museum and the New York State Museum, and he became highly influential in the development of curatorial techniques after World War II. His publications, *So You Want a Good Museum* (1957) and *The Management of Small History Museums* (1959), were standard references for many years.

Another development in the making of archaeological collections was that field schools, such as those taught by Fay-Cooper Cole at the University of Chicago, became a venue for archaeological fieldwork. Anthropology departments thus became responsible for the curation of the archaeological collections they made, although this responsibility often fell to the individual faculty member—a situation that continues today in many academic institutions.

Cole had worked at the Field Museum before going to the university. As a faculty member, he developed a program of archaeological research in Illinois as a training ground for graduate students in anthropology. A major part of Cole's program was summer field schools, which he ran for nearly a decade. These field schools were instrumental in developing modern archaeological field techniques, including the development of systems of horizontal and vertical control, techniques for excavating mounds and villages, and systematic record keeping on detailed forms (M. Fowler 1985). Cole's emphasis on scientific data collection procedures, including systematic excavation and recording techniques, also apparently instilled in his students a respect and preservation ethic for the collections they made (Sullivan 1999). However, archaeological fieldwork and postfieldwork curation continued to diverge.

EARLY FEDERAL ARCHAEOLOGY
PROGRAMS: 1930S AND 1940S

The New Deal's public works projects of the 1930s profoundly affected archaeological fieldwork and curation. In many regions, university anthropology departments, sometimes in conjunction with university museums, conducted large field projects that provided work for the unemployed. These federal projects had significant impacts on U.S. archaeology, both in creating extremely large collections that now serve as major data banks and in formulating new techniques, methods, and theories. A few of these projects actually spawned museums and filled them with large collections, but long-term curation was not part of the New Deal–era programs.

The curatorial fate of collections from these projects runs the full spectrum of possibilities. At one extreme, some collections still are unwashed. At the other, the work of vigilant and determined individuals resulted in construction of repositories to care for these materials. Regardless of condition, the New Deal–era collections and records contain a wealth of information pertinent to current archaeological problems as well as to historical research about the development of the discipline. They can be highly useful, if they are accessible.

A major concern of archaeology during the 1930s was formulation of regional syntheses. These were based on experimental chronologies and culture classification schemes without the benefit of absolute dating techniques. The antiquity of the archaeological record in the Americas was not yet known, nor was the existence of the eastern Archaic or Paleoindian fully recognized. Classification schemes were developed to define archaeological complexes based on associated traits in an attempt to gain some spatial-temporal control over the data. For example, pottery typology became an important tool in these classification schemes. Different suites of pottery styles became associated with (and often definitive of) archaeological complexes that many researchers viewed as actual "cultures." A widely used system was the Midwestern Taxonomic Method, developed and advocated by W. C. McKern of the Milwaukee Public Museum. The 1930s also saw experiments with new field methods and techniques to improve recovery of contextual and functional information (Fairbanks 1970).

The federal work programs of the Great Depression fostered the attitude that fieldwork was more valuable than curation because the

programs' goal was to put many people to work, and archaeological fieldwork is labor-intensive. While laboratory work, data analysis, and publication initially were not viewed as acceptable costs, long-term curation was not even considered to be a part of these programs. Another rather insidious aspect of the devaluation of archaeological curation during the Depression had to do with sexist cultural mores. Curatorial duties and lab work often fell to women in the federal work programs, reinforcing marginalization of both the work and the workers (White et al. 1999).

The movement of field projects from museums to universities also may have influenced the curation prejudice. While universities often have tended to see field training of students as an integral part of their missions, the maintenance of research collections has been seen as peripheral. Such a view reinforces differential valuing of making versus caring for collections.

The historic preservation movement, which began in the late nineteenth century and became intertwined with archaeology in the 1930s, also contributed to the curation prejudice. The goal of the movement initially was to preserve historic buildings. The architects and architectural historians who led the historic preservation movement and who drafted the historic preservation laws that pertained to archaeological sites did not adequately address the curation of collections such as those produced by archaeological research. Mention of collections in the Historic Sites Act of 1935 was relegated to a general empowerment of the secretary of the interior, through the National Park Service, to "secure, collate, and preserve drawings, plans, photographs, and other data of historic and archaeologic sites, buildings and objects." The fact that artifacts and specimens were not mentioned reflects the lack of involvement of archaeologists in crafting this law. More significantly, where and how these "data" were to be secured, collated, and preserved was not specified (T. King 1998; T. King et al. 1977).

A CASE STUDY: THE CHICKAMAUGA BASIN PROJECT

A case study of one New Deal project helps us appreciate early federal archaeology programs in terms of curation-related problems in program administration, the kinds of information that are available from this era, and the kinds of materials that currently are being curated. The Chickamauga Basin project in southeastern Tennessee (Lewis et al. 1995) not only laid the groundwork for

much subsequent research in the Upper Tennessee Valley, so much so that the archaeological phases in the region are named for sites in the Chickamauga Basin, but also helped build an infrastructure for archaeological research in the state. The collected information is the only systematic documentation of major sites that now are inundated or destroyed. These collections thus exemplify the need to ensure that archaeological materials are preserved and accessible for future scholars.

The Chickamauga Basin project was one of several archaeological projects conducted in conjunction with the construction of reservoirs by the Tennessee Valley Authority (TVA). Archaeological work for the Chickamauga reservoir on the Tennessee River near Chattanooga began in early 1936 and continued through 1939. A survey of the basin, conducted under the direction of William Webb of the University of Kentucky, located some seventy sites. Thirteen multiple-component sites were chosen for excavation. Thomas M. N. Lewis, who had been hired by the University of Tennessee in 1934 as its first archaeologist, ran the project under the newly established Division of Anthropology, a section of the History Department. Lewis was from Wisconsin and had worked with W. C. McKern at the Milwaukee Public Museum (Sullivan 1999).

A new federal relief program, the Works Progress Administration (WPA), provided the labor. Lewis hired young archaeologists from several universities as field supervisors, including several of Cole's University of Chicago students who would go on to become well-known archaeologists. Jesse Jennings was the main supervisor. The large WPA crews (fig. 2.1) made it possible to excavate huge areas, and as Lewis notes in the project's manual of field and laboratory procedures, the field supervisors had to expend "much shoe leather" to keep up with the excavations. The excavated sites included five Mississippian platform mounds, eight Late Woodland burial mounds, sixteen Late Woodland shell middens, a multicomponent Woodland midden, and portions of nine Mississippian villages and one historic Cherokee village. Nearly 2,000 burials and 165 structures were excavated, mapped, and photographed (Sullivan 1999; Lewis et al. 1995).

Dealing with the collections was an issue from the start of the TVA-WPA work because multiple institutions and personalities were involved and suitable laboratories and repositories were lacking. William Webb, a physicist interested but not formally trained in archaeology, ran the first TVA reservoir project in the Norris Basin. At the end of that project, TVA gave the artifacts to the University of

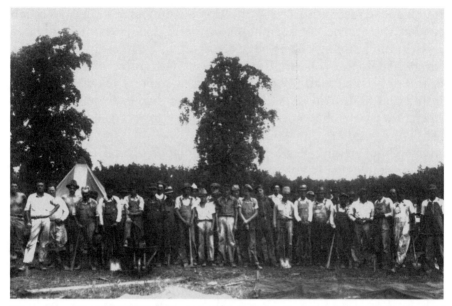

Figure 2.1. One of the WPA field crews that worked in the Chickamauga Basin. The field crew members were almost always male. Stuart Neitzel and Charles Fairbanks (at left) were the University of Chicago–trained site supervisors.

Tennessee, which at the time did not have a repository. Webb took the osteological collections and field records to the University of Kentucky, which had established an archaeology program and lab in the 1920s (Lyon 1996). This probably was not the first example of an unfortunate split of materials that should have been curated together. It certainly was not the last.

Webb became the TVA archaeological consultant and resisted spending money on laboratories to process collections. He did so because the government was not legally required to do archaeology and because he feared that requests for large sums of money would be an impetus to end the projects. It was not until 1938 that the WPA archaeological program was restructured to support laboratories, analysis, and publication. By the time this could be done in Tennessee, the Chickamauga laboratory work was three years behind the fieldwork. Boxes of artifacts were piled up in the laboratory, and there was a large backlog of uncataloged and unanalyzed materials.

In 1938, near the end of the Chickamauga fieldwork, Lewis hired Madeline Kneberg, a student of Cole, to be lab director. Her goal for the laboratory work was to catch up with the fieldwork. She oversaw materials preparation, restoration, and cataloging, as well as analysis.

The Tennessee lab had forty workers and six supervisors (mostly Chicago students) at its peak in 1939–1941.

Artifacts were cleaned in the field and shipped to the Knoxville laboratory. The lab then cataloged and analyzed the collected materials with the assistance of several specialists from other institutions. Under Kneberg, the lab also developed an innovative attribute-based system for artifact classification, a technique for pottery vessel reconstruction, and numerous card files for analytical purposes and collections management. For the Chickamauga project alone, the lab classified over 360,000 pottery sherds and some 100,000 stone, bone, shell, and copper artifacts; identified almost 7,000 animal bones to species; reconstructed several hundred pottery vessels; and examined all of the nearly 2,000 recovered skeletons for age, sex, and pathologies.

Lewis and Kneberg wrote a manual that described the field and laboratory methods used by the Tennessee projects. The field methods were largely derived from systems developed by Cole's field schools but also included techniques developed under Lewis's supervision and experimentation. The manual also explained Kneberg's complicated catalog and file system that was used to preserve provenience and contextual information and to prepare data for publication.

The entry of the United States into World War II interfered with project publication goals, as New Deal projects were shut down and many of the staff were drafted for the war effort. In 1946, the University of Tennessee Press published a report by Lewis and Kneberg on one excavated site, Hiwassee Island, but the report for the entire project remained in incomplete draft form until 1995. The curated project records made it possible to complete and publish this important document (Lewis et al. 1995).

Although the New Deal archaeology programs eventually did provide for laboratory processing and analysis of collections, they did not provide for long-term curation. This was a particular problem in Tennessee where no state or university museum or repository existed. To house the vast collections resulting from the University of Tennessee WPA work, and to provide the growing anthropology program with a home, Lewis and Kneberg convinced the university to build a museum. Lewis had been an advocate for a museum supported by the State of Tennessee ever since the university hired him. The Frank H. McClung Museum finally was built in 1960 with private funding donated to the university, some two decades after the end of the New Deal archaeology projects (Sullivan 1999) (fig. 2.2). The McClung Museum continues to curate the

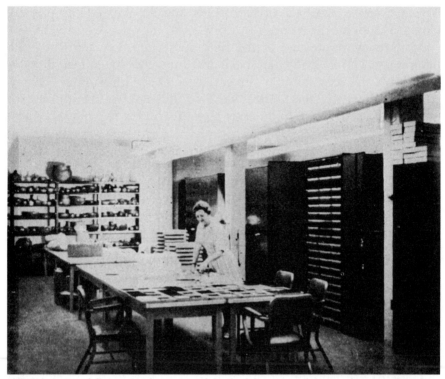

Figure 2.2. Madeline D. Kneberg at work in the laboratory of the Frank H. McClung Museum. Many of the pots on the shelves behind her are from the WPA excavations in the Chickamauga Basin. The museum was established and built in the 1960s, some thirty years after the WPA investigations. Kneberg's and Thomas M. N. Lewis's long-term and persistent advocacy were essential factors in getting an appropriate repository for these collections.

Chickamauga Basin collections and remains the major repository of archaeological collections from Tennessee.

The Chickamauga collections are suitable for a wide range of research because of the systematic and standardized collecting and recording techniques, preservation of within-site provenience information, and large samples of various materials (see Cantwell et al. 1981) (fig. 2.3). The collections are especially precious because the opportunity for continued excavation no longer exists at most of the sites. Examples of the kinds of data available from the Chickamauga Basin include: documentation of large portions of villages showing spatial relationships between structures and other features, plan drawings of many structures, large and detailed data sets for studies of mortuary practices and human biology, and large numbers of intact artifacts for technological and stylistic comparative studies

Figure 2.3. Examples of the records made by the Chickamauga Basin Project, including a plan map of the Dallas site (a Mississippian village), a feature form for a structure on the Dallas site mound, 3.5 × 5–inch photographs of the mound structure (the original negatives are silver nitrate), and a ceramic analysis card showing the pottery counts from the mound structure (written in the abbreviation code developed in the WPA lab). The records are now invaluable components of the Chickamauga Basin collections and must be curated in perpetuity.

(Lewis et al. 1995). A number of dissertations and theses have relied on data from the Chickamauga Basin collections but certainly have not exhausted their potential. One wonders what would have happened to these significant and irreplaceable collections if the McClung Museum had not been built.

THE POSTWAR CONSTRUCTION BOOM AND THE "NEW ARCHAEOLOGY": 1945 TO 1970

The postwar construction boom had major impacts on American archaeology. Sites were being lost at unprecedented rates. Dams began to be built throughout the country immediately after the war. Clearing and leveling of agricultural lands were extensive during the 1950s and 1960s under federal cost-sharing programs. The Eisenhower administration began building interstate highways in the 1950s. "Urban renewal" of the early 1960s began leveling older sections of cities. Archaeologists scrambled to save sites and to get federal legislation passed to stop the rampant destruction (T. King 1998; T. King et al. 1977). Site salvage was the battle cry of the day; no one had time to

think about what was to happen to the materials once they were saved from the bulldozers.

The River Basin Salvage Program was one federal archaeology program developed in response to these massive construction projects. It began in 1945 at the Smithsonian Institution. Through a memorandum of understanding between the Smithsonian and the National Park Service (NPS), institutions in several states were contracted to do surveys for archaeological sites that would be affected by Bureau of Land Reclamation and Army Corps of Engineers reservoir projects (Friedman and Storey 1999). The program was modeled largely after the WPA programs, was authorized under the Historic Sites Act of 1945 (16 U.S.C. 461–67) (T. King 1998; T. King et al. 1977), and, not surprisingly, lacked any specific provisions for long-term curation of the collections.

The NPS gradually became the lead agency in the reservoir salvage effort, and its Interagency Archeological Salvage Program assumed much of the administration of the reservoir projects. The federal Reservoir Salvage Act of 1960 (16 U.S.C. 469) formalized this role (T. King 1998). This law mentions, almost as an afterthought, "The Secretary [of the Interior] shall consult with any interested Federal and State agencies, educational and scientific organizations, and private institutions and qualified individuals, with a view to determining the ownership of and the most appropriate repository for any relics and specimens recovered as a result of any work performed as provided for in this section." Unlike the 1906 Antiquities Act, the kinds of institutions to serve as repositories were not named, the public educational value of collections and accessibility issues were not mentioned, and the critical need to make curation arrangements prior to fieldwork was ignored. Curation definitely was not a front-burner issue as salvage archaeology became a substantial part of the fieldwork being done in the United States.

A number of laws passed in the 1960s provided for archaeological assessments before construction projects (see Toolkit, volume 1). The most comprehensive was the National Historic Preservation Act of 1966, which required federal agencies to consider the effects of their undertakings on historic properties, including archaeological sites. Other laws, including the National Environmental Policy Act of 1969, and portions of laws pertaining to the Departments of Transportation and of Housing and Urban Development also required such considerations. None of these laws, however, provided specific guidance on the curation of the resulting archaeological collections.

Not only was the amount of archaeological fieldwork increasing in the 1960s, but also the discipline of archaeology was changing in

ways that resulted in the collection of more materials. Archaeologists began to ask new kinds of questions of the archaeological record and to devise techniques for collecting new kinds of samples and materials to answer these queries. The "New Archaeology" investigated aspects of human behavior and processes of culture change. It asked questions about environmental and social relationships, and it used systematically collected data to answer them. This approach contrasted with more descriptive and classificatory approaches that sought to characterize past cultures through regional syntheses based on artifact types (Willey and Sabloff 1977). For example, the new emphasis on human relationships with the natural environment stimulated detailed analysis of the uses of wild versus domesticated plants. A technique new to archaeology, flotation, allowed recovery of carbonized plant materials from soil samples. New emphasis was placed on sieving archaeological deposits through fine-mesh screens to enable recovery of small-scale specimens. Such new techniques greatly increased the kinds of information that could be gleaned from archaeological sites (see Toolkit, volume 5). They also produced more and different kinds of materials to be curated. By the early 1970s, the fact that there were significant problems with curating archaeological collections was becoming widely apparent (Ford 1977).

MAKING VERSUS CARING FOR COLLECTIONS: THE 1970S AND BEYOND

The segregation of making and caring for collections and lack of consideration of long-term curation issues continued to be problems in the 1970s, in relation both to federal preservation laws and to the profession of archaeology (Lindsay et al. 1980). Chapter 3 provides an in-depth look at the history of the laws and how they influenced the current curation situation. For now, we can say that these laws dramatically increased the amount of archaeological fieldwork done in the United States, so the amount of material to be curated also dramatically grew. Repositories, including museums, saw their collection storage areas fill to capacity with no means to properly store, catalog, or inventory the materials. These increases, on top of the previous three decades of large federal programs with no support for curation, were leading to a major crisis.

Attitudes and assumptions among professional archaeologists and curators also affected collections care in the 1970s. Academic

archaeologists in particular often assumed that storage areas could be found for collections. Usually, it did not cross their minds to arrange for care ahead of time or that collections required more than just storage. These attitudes and practices were, and still are, prevalent because curation was rarely discussed at professional meetings or taught in graduate schools. Furthermore, university anthropology departments often were unable to secure curatorial space because collections care typically was (and is) not an institutional priority. Important collections, therefore, were relegated to dank, dark basements; asbestos-coated surplus warehouses; old and unrenovated army barracks; and mice-infested and leaky barns (Trimble and Meyers 1991). After saving collections of artifacts from destruction in the field, archaeologists were permitting the loss and degradation of their research value out of the field.

Another development that has contributed to the segregation of making collections and curating them relates to the fact that private consulting firms, instead of university anthropology departments, began to do much of the field archaeology in the United States in the late 1970s. Because such firms are not directly tied to museums, their field projects often are done without the direct involvement, support, approval, or supervision of the repository that will be the custodian of the collection. The priority of cultural resource management is largely the sites in the field, not the collections that are the legacies of those sites. This focus is understandable due to the realities of site loss, but severe problems arise when the ultimate destiny of the resulting collections is not considered as part of the entire project.

Further separation between collecting and curating is occurring because collections management is becoming a specialized profession. The museum curator who commonly served as all-purpose researcher, collections caretaker, conservator, and exhibit designer in earlier decades still survives in small museums. But these tasks cannot be done by one person in the larger museums that are usually the primary repositories for research and federally owned collections (even though budget cutting may force a return to the days, and problems, of the do-it-all curator). Furthermore, collections managers today are not necessarily trained archaeological researchers. Even when they are, they cannot be expected to have expertise in the multiple research specialties of modern archaeology (Sullivan 1992a). Also, each one of the many kinds of repositories has a different mandate, different audiences, and different collections policies (see chapter 4).

CONCLUSION

Attitudes and practices in field collecting and collections care have changed over the last hundred years. The changes are not inherently bad. One positive aspect is that collections are now beginning to be cared for by professionals who are trained for this work. Many people and institutions often are involved in activities that once were done by single individuals or institutions. The problems of earlier federal programs can be avoided if all parties coordinate their efforts and plan specifically for collections care. Successful long-term curation should not have to depend solely on the persistent efforts of determined individuals, as was the case with the New Deal–era collections in Tennessee.

Recent efforts are bringing us to a different place today, as we shall see in chapter 3. Many collections are housed in improved storage conditions, and we have better information on the contents of many collections. We also have increased public accountability for collections care and use. However, archaeologists cannot afford to proclaim the issues resolved, given that collections continue to grow and require sustained support. A major question for the twenty-first century is, How do we manage this growth so that collections care does not mean loss of significant research materials or a return to substandard basements, barns, and warehouses? We've been there, done that. What can we learn from these experiences?

Archaeologists and repositories have learned two important lessons over a long period of time, and the hard way. One lesson is that proper care of collections does not just happen. Collections must be managed by knowledgeable staff with adequate facilities and support at their disposal. The other lesson is that good curation costs real money, a resource that is chronically scarce in archaeology (Marquardt et al. 1982; McManamon 1996). In the next chapter, we will learn more about how a national curation crisis developed and about the efforts that are being made to correct this situation.

THE CURRENT STATUS OF ARCHAEOLOGICAL COLLECTIONS

The vast majority of archaeological collections around the United States are now under federal or state ownership and are in a state of crisis. As we saw in chapter 2, significant problems began during the New Deal era. As we shall explore here, problems accelerated in the 1970s and early 1980s, influenced by at least three factors.

One factor was the historic preservation movement. As museums and archaeology were developed and professionalized, support slowly increased for historic preservation. The movement emphasized many tangible and valuable products of past cultural systems that deserved to be preserved for the benefit of future generations (T. King et al. 1977). The focus was primarily on historic properties, including archaeological sites and the data they contained. Unfortunately, the logical relationships between the preservation and conservation of historic properties and the associated collections, records, and reports preserved in museums and repositories were not well made.

Another factor more specific to the discipline of archaeology was the ethic of conservation (Lipe 1974; McGimsey and Davis 1977). The earlier ethic of excavation had encouraged the destruction of sites through research and salvage excavations in order to learn as much as possible about past cultures. This information was then supposed to be shared within the archaeological community. The conservation ethic taught that archaeological sites are nonrenewable and irreplaceable, that the maximum amount of information must be retrieved from each project, and that some sites must be conserved and preserved for future use. It encouraged careful long-term management of those resources so that well-informed decisions could be made about

their significance, survival, and best use. The conservation ethic also encouraged more communication between archaeologists and the public about the results of excavations and their relevance to the public. Although understated, there was some realization that the collections and records resulting from archaeological projects would become increasingly valuable and useful as sites were destroyed for both research and compliance (Christenson 1979; Marquardt 1977a; McGimsey and Davis 1977:63).

Native American concerns are a third factor that will affect archaeological sites and collections well into the future. Native peoples protested against excavation of their sacred and ancient places, insensitive treatment of their ancestors' skeletal remains in museum storage boxes and exhibits, and the poor care of Native American archaeological and ethnographic museum collections in general. While it was recognized that Indian cultural centers did not meet minimum museum requirements for storage and display, Native Americans complained that neither did many of the museums and repositories holding archaeological collections (McGimsey and Davis 1977:94).

In this chapter, we examine the federal and state legislation enacted in response to these concerns, including their intended effect on the care and maintenance of archaeological collections, records, and reports. We then outline the urgent issues affecting archaeological collections today that have emerged from legislative efforts and archaeological practice. Finally, we discuss the progress that has been made.

FEDERAL LEGISLATION AND POLICY

The Archeological and Historic Preservation Act (AHPA) of 1974 (the Moss-Bennett Act) called for "the preservation of historical and archaeological data (including relics and specimens) which might otherwise be irreparably lost or destroyed as the result of . . . any Federal construction project or federally licensed activity or program." AHPA stipulated that up to 1 percent of the costs of a federal project could be spent on the recovery, protection, or preservation of endangered data. This act also stated that the secretary of the interior must consult with designated groups or individuals "with a view to determining the ownership of and the most appropriate repository for any relics and specimens recovered as a result of any work performed." AHPA called for the secretary of the interior to issue regulations for

the long-term curation of significant artifacts and associated collections, thus beginning action to rectify the lack of curation planning for federal archaeology discussed in chapter 2.

Five years later, the Archeological Resources Protection Act of 1979 (ARPA) was passed. ARPA acknowledged the national problems involving the preservation and care of huge numbers of sites and collections, and it supplied a modicum of help for collections. First, it clearly stipulated that sites and objects from public lands were the property of the United States. Second, it called for the preservation of objects and associated records in a "suitable" institution, implying that an institution had to meet some sort of minimum curation standards. Third, it permitted the secretary of the interior to issue regulations about the exchange and ultimate disposition of archaeological collections.

Unfortunately, the regulations entitled *Curation of Federally-Owned and Administered Archeological Collections* (36 CFR Part 79) were not issued until 1990. In the meantime, a Government Accounting Office (GAO) report entitled *Cultural Resources—Problems Protecting and Preserving Federal Archeological Resources* (GAO 1987) clearly showed that the curation crisis was already in full swing: repositories were understaffed, overstuffed, and underfunded. The report strongly urged the promulgation of standards and guidelines to rectify this situation.

When finally issued, the regulations clearly assigned responsibilities to the federal agencies who owned archaeological collections and provided considerably more guidance than had been previously available. These guidelines have served as a model that agencies could use to develop more specific policies, and some agencies have done so (e.g., the U.S. Army Corps of Engineers, several bureaus of the Department of the Interior, and the U.S. Air Force). Table 3.1 summarizes key components of the regulations.

Within a month of the promulgation of the curation regulations, the Native American Graves Protection and Repatriation Act (NAGPRA) was passed. NAGPRA responds to American Indian concerns regarding the treatment of their ancestors' remains and significant related collections. It provides a procedure for the repatriation of Native American, Native Hawaiian, and Native Alaskan human skeletal remains, funerary objects, sacred objects, and objects of cultural patrimony that are currently held by federal agencies or by museums that receive federal funds (McKeown et al. 1998). If cultural affiliation can be identified between a particular set of prehistoric or historic remains

Table 3.1. Key Components of 36 CFR Part 79

1. Its legal authorities (Reservoir Salvage Act, Section 110 of NHPA, and ARPA)
2. Guidelines for the long-term management and preservation of preexisting and new collections
3. Methods to obtain curatorial services, such as
 - placing a collection in a federal repository
 - entering into a cooperative arrangement through a formal agreement with a non-federal repository
 - transferring a collection to another federal agency
 - requiring permitted projects on public or Indian lands under the Antiquities Act or ARPA to provide for curatorial services as a condition of the permit
4. Methods to fund curatorial services by federal agencies, such as
 - using funds appropriated by Congress for specific activities at a federal, state, or nonfederal repository
 - charging licensees and permittees reasonable costs for curatorial activities as a condition of the license or permit
 - placing collections in a repository that agrees to provide curatorial services at no cost to the U.S. government
5. Terms and conditions for curatorial services to include in contracts, memoranda, and agreements
6. Standards to determine if a repository can provide adequate long-term curatorial services, such as
 - professional museum and archival practices to accession, label, catalog, store, inventory, and conserve collections
 - maintenance of complete and accurate records on collections, as well as the
 - protection of documents from fire and theft
 - dedicated space to properly store, study, and conserve collections
 - secure storage, laboratory, study, and exhibit areas for collections
 - qualified museum professionals to manage and preserve a collection
 - collections inspections and inventories
 - access to collections
7. Scientific, educational, and religious uses of collections, including some conditions and restrictions
8. Procedures for conducting inventories and inspections

and a present-day Native American tribe, Native Hawaiian organization, or Native Alaskan corporation, or if the lineal descendants request the return of those remains, the federal agency or museum must do so as quickly as possible.

In many ways, NAGPRA has had a more positive impact on the current and future status of archaeological collections than the regulations in 36 CFR Part 79. This is because NAGPRA demanded that every federal agency and federally funded museum conduct an inventory to determine the contents of its collections and to address the

ownership of specific items. Institutions had to meet specific deadlines for compliance or be subject to penalties. NAGPRA also provided some much needed funding to assist museums and tribes in the mandated process. Finally, NAGPRA has forced archaeologists and curators to cope with a dreaded and contested process: deaccessioning of items, in this case through repatriation.

So there is both good news and not-so-good news concerning the current status of archaeological collections and curation. The not-so-good news first: Early laws promoting archaeology did not provide guidance or direction on long-term collections management or how to make collections publicly accessible and useful. As discussed in chapter 2, early federal archaeology programs had no curation plans, and large collections were inadequately cared for. Most federal agencies with collections relied on the good graces of nonfederal repositories to manage their collections for free. In return, the repositories had little interaction with or interference from the agencies, and their staff had immediate access to the materials for research and interpretive projects.

This trend has continued. For example, the U.S. Army Corps of Engineers spent approximately $165 million on archaeological projects between 1975 and 1990 and virtually nothing on curation (Trimble and Meyers 1991:3). Few people anticipated the quantities of new collections that would be created, the storage space that would be required, or the curatorial effort necessary due to the National Historic Preservation Act and the Archaeological and Historic Preservation Act.

The good news is that 36 CFR Part 79, as well as NAGPRA and its implementing regulations (43 CFR Part 10), directed more attention to collections. Specifically, 36 CFR Part 79 provided guidance on establishing formal relationships between agencies and repositories for long-term care. It also acknowledged the costs involved, including the obligations of federal agencies to pay for curation. Because NAGPRA required an inventory of human skeletal remains, funerary objects, sacred objects, and objects of cultural patrimony, federal agencies had to figure out what they owned and where it was all located. Repositories were compelled to identify the owners of the collections under their care. The creation of better inventories has yielded knowledge of the collections' contents, storage locations, and conditions, as well as better access to them for research and interpretation. Finally, both 36 CFR Part 79 and NAGPRA have reinforced the need for collections policies, repository mission statements, and records management systems for both the owners of collections and the repositories.

Let us now examine some of the specific effects of the legislative efforts and the related issues that have been raised within the archaeological and museum professions over the last twenty-five years.

KEY ELEMENTS OF THE CURATION CRISIS

A few voices began to identify trouble concerning the storage and care of archaeological collections, records, and reports as early as the mid-1970s (Ford 1977; Marquardt 1977a). Concerns included inadequate care and visible deterioration of existing collections, inaccessibility to collections for research due to poor or nonexistent inventories or catalogs, and little or no security to protect the collections (Ford 1977; Lindsay et al. 1979). Some collections, such as some from WPA projects of the 1930s, were uncleaned and unanalyzed, and they had no associated project reports (T. King et al. 1977:24).

Several other concerns were related to archaeological practice. A critical problem, which continues today, was that archaeologists were not taking responsibility for the collections they generated (Christenson 1979; Marquardt 1977a; Marquardt et al. 1982). Excavation activities and research interests almost always had higher priority than curation of collections (Lindsay et al. 1980:93). This situation was exacerbated by the fact that field projects were largely run by universities without collections facilities or mandates to care for collections, as noted in chapter 2. The primary focus of graduate programs was on research accomplished through excavation or survey rather than collections. Virtually no courses in archaeological curation or collections management existed, nor do they today. The subliminal message from many graduate programs was and still is that the long-term preservation and care of collections are not the concerns of archaeologists but are the responsibility of curators or collections managers as soon as a collection is delivered to a repository.

Also in the late 1960s, new classes of materials, such as soil and botanical samples, were collected to help reconstruct the environmental contexts of past cultures, as noted in chapter 2. In the past, collections often were culled. For example, WPA researchers counted and then discarded all the plain, shell-tempered body sherds from the Chickamauga Basin collections (see chapter 2) because the analytical value of these materials was viewed as negligible and curatorial space was limited. Over time this practice became regarded as unethical. Instead of discarding large amounts of material after analysis, "every-

thing" was saved for maximum information yield and to build up a data bank of materials in anticipation of changes in intellectual foci and new analytical techniques (Dunnell 1984; Sonderman 1996; Woosley 1992).

During the 1970s, increasing numbers of projects yielded only unpublished technical reports with little interpretation (McGimsey and Davis 1977). Few results of salvage and cultural resources management work were accessible through widely distributed, formal publications. Instead, information resided in reports of very limited circulation that were not cataloged or available in most libraries (see Toolkit, volume 7). Because project results and reports are poorly known, they rarely contribute to the goals of archaeology in general or interpretive syntheses for particular regions and themes. Also, new projects may duplicate previous work. However, these limited-distribution reports often provide the only information about projects, including critical contextual and locational data needed for proper use of the resulting collections. Therefore, timely production, widespread awareness, and access to copies of this "gray" literature are of considerable concern (Lipe and Redmond 1996).

By the early 1980s, new collections from cultural resource management (CRM) work began to pour into repositories, and cries for help focused on the new materials. Some repositories were already full and could not take in any new collections. For other repositories, the rate of acquisition became overwhelming because they did not have the staff or the funding base to do the required cataloging, information management, conservation, and storage work (Bell 1990; Marquardt et al. 1982; McGimsey and Davis 1977). Some of the issues mentioned earlier became exacerbated, while other significant concerns began to appear: ownership, standards, professional responsibilities, costs, information management, management of associated records, NAGPRA and consultation, deaccessioning, illicit trade, and repository certification. A national initiative on curation also has been proposed. Each of these issues is addressed next.

OWNERSHIP

Ownership of artifact and document collections is a significant issue in light of the wide range of collection owners, differences in their responsibilities, and confusion over who owns what over time. Owners of archaeological collections include federal, state,

and local agencies, federally recognized tribes, CRM firms, museums and repositories, university departments, individual researchers, and private landowners. In many cases, dependency relationships have formed between groups, blurring the ownership of specific collections.

Federal agencies, federally recognized tribes, museums that have received federal funding, and some state agencies have specific legal responsibilities for the collections they own. For federal and many state and local agencies, these responsibilities include the following:

- Identifying repositories that meet minimum curation standards, negotiating conditions of long-term care, and depositing collections in those repositories
- Funding long-term care of both new and existing collections
- Inventorying collections
- Providing access to the collections in order to meet demands for public accountability and use

Federal agencies and institutions that have received federal funding must comply with NAGPRA. Although most agencies and institutions submitted their NAGPRA collection summaries in 1993 and inventories in 1995, they are still involved with consultation and repatriation processes that require staff expertise and funding. Federally recognized tribes must meet the requirements of laws and regulations such as ARPA and 36 CFR Part 79, but requirements for tribes are less well defined than those for federal agencies. Other organizations, such as CRM firms working on nonfederal and nonstate projects, many private and university museums, individual researchers, and private landowners, control the destiny of their collections, often with few policies or standards for long-term care. When compliance and mitigation work is done by a federal or state agency on private land, the landowner has full rights to the collection. The landowner may waive these rights and formally donate the collection to a repository. Archaeologists and agency staff who work with private landowners should encourage them to donate their collections to a repository that meets the standards of 36 CFR Part 79.

Given the number of owners of archaeological collections, the increasing costs involved in their care, and the inconsistent controls over long-term collections management and care, ownership sometimes has become contentious. For many decades prior to 36 CFR Part 79 and NAGPRA, museums and repositories curated federal collec-

tions for free in return for immediate access to them for research and exhibit. Now, in times of shrinking budgets, increased sizes and numbers of incoming collections, and stricter curation legislation, many repositories want federal agencies to acknowledge ownership and be fully accountable for funding collections care. Many repositories also want agencies that cannot do so to give up ownership. Agencies should know what they own and where it is located, while repositories should be able to identify and locate a specific collection and know its owner. Unfortunately, government agencies often have very poor records on their collections (Ferguson and Giesen 1999; GAO 1987). Repository inventories, when available, have been primarily designed to enable research, not to identify ownership (Bell 1990:9), so many repositories have not been able to determine who owns the collections under their care (Meyers and Trimble 1993; Trimble and Meyers 1991). Ownership remains unclear in such cases.

Federal and state agencies have had to work with each other to determine ownership where, for example:

- land ownership changed between agencies;
- several agencies involved in one project had different responsibilities for permitting, funding, land management, and project work;
- multiple funding sources supported a project; or
- agencies disagreed over their involvement in a project.

Indian tribes have ownership rights to whole collections excavated on Indian lands, as well as specific items in federal collections, since the passage of ARPA and NAGPRA. Controversy over rightful ownership can occur between tribes during the NAGPRA consultation and repatriation process or due to privately owned holdings of land on many reservations. Federal or state agencies may share ownership of an archaeological collection with private landowners because it is within the rights of a private landowner to keep a portion of a collection and donate the remainder to a repository.

Ownership of collections will remain a problem in U.S. archaeology due to the responsibilities and costs involved. Given the costs of long-term care, agencies may fight to *lose* ownership rights! Because the laws and regulations are now more explicit about ownership, some controversy may dissipate as experience is gained, formal partnerships and cooperative agreements are created, viable models of cooperation are made public, and inventory and records management systems are improved.

STANDARDS FOR COLLECTIONS
MANAGEMENT AND CARE

By the mid-1970s, considerable variation existed in the quality of short-term and long-term care that repositories provided for the collections they owned and those they managed for others. These disparities grew as new collections accumulated. To minimize the variability and stabilize the collections for better access and use, a few archaeologists advocated establishing criteria or standards to evaluate and improve the quality of collections care, repository facilities, curatorial services, and management controls (Lindsay et al. 1979, 1980; Marquardt 1977a; McGimsey and Davis 1977). The early criteria were general, noting the needs to retain systematic collections for research purposes, have storage facilities with conservation facilities and climate control for different materials, have record keeping for accessibility and security, and provide educational services (McGimsey and Davis 1977). Explicit standards for initial collections processing and long-term collections management were subsequently advocated (Marquardt et al. 1982). Proposed standards for archaeologists depositing a collection for curation included submission of:

- a complete catalog of objects;
- original or clear copies of all associated field records, photographs, maps, and related documents; and
- objects in a stabilized and/or conserved condition.

Repositories that accepted new collections were expected to manage accessioned collections using an information management system that, at a minimum, provided locational information for research and management (computerization was not seen as mandatory in the early 1980s). The repositories also should package, label, and store collections in a pest-free, secure, and appropriately climate-controlled area. For long-term collections management, proposed repository standards included:

- good physical integrity of the building with special-use space and health, fire, and security measures;
- an information management system to search and retrieve items from all collections and to update records; and
- staffing expertise based on the size of the repository.

Many of the collections care and management needs recognized by these proposed standards were reiterated in a later analysis of the substandard conditions of federal collections held in several southwestern repositories (GAO 1987).

The issuance of 36 CFR Part 79 in 1990 finally provided a needed minimum set of curation standards and practices to be met by all federal agencies and the repositories with which they partnered. The regulations cover the issues presented earlier, along with the need for a repository mission statement, collections policy, and records management policy. Unfortunately, however, the regulations do not establish standards for inventorying collections and their associated records to improve their identification and accessibility. The regulations do not require periodic inventories or deadlines for compliance by repositories. Nor do they establish a certification process to help agencies identify repositories that meet the minimum standards. Some felt that these additional requirements would slow down the promulgation of the regulations and add considerable burden and expense to those affected by the regulations (Ferguson and Giesen 1999).

Some federal agencies (e.g., U.S. Army Corps of Engineers, U.S. Air Force) have used the minimum set of standards in 36 CFR Part 79 as a foundation on which to develop more specific standards. As a result, some curators discovered that agencies that share space in the same repository have different sets of requirements the repository must meet (Bell 1990). Similar problems exist for the agencies that have collections in many different repositories, each with its own collection management requirements.

PROFESSIONAL RESPONSIBILITIES

"Curation is a professional responsibility; we must argue for it, insist on it, teach it, believe in it, and practice it" (Marquardt 1977a:39). Unfortunately, many archaeologists still do not consider the long-term care of collections to be as important as the sites from which the objects were recovered. Farnsworth and Struever (1977:13) bluntly note that "deep down inside many of us is the belief that the first analysis is equivalent to the last analysis of any body of archaeological data. When the analysis is done, why curate?" As a consequence, archaeologists often regard curation as a storage problem, not as a process of banking irreplaceable data, objects and documents, as a basis for research and education, and as a foundation of cultural heritage (Sullivan 1992a, 2001).

Three things need to happen to rectify professional attitudes. The first involves education and training. Basic archaeological collections management must be a required course in graduate archaeology programs so archaeologists learn their responsibilities and understand the long-term impact of their actions (see the appendix for information on an online course on archaeological curation). Such course work should encourage some students with a good grounding in archaeology to pursue a career in archaeological curation and collections management. Training in the conservation of objects and documents, information management and databases, and archiving also must be facilitated and valued by the archaeological profession. Recent discussions of new curriculum reforms for graduate archaeology education do not include collections curation (Bender and Smith 2000; Lynott et al. 1999). On the positive side, the Society for Historical Archaeology (SHA) has a collections management committee and a set of curation standards for SHA members (SHA 1993), and the Society for American Archaeology established a curation committee in 1999 and approved new ethical guidelines regarding curation in 2002 (Childs 2002).

The second need is to increase the number of curatorial jobs in repositories and in large cultural resource management firms to handle the significant workload (McGimsey and Davis 1977). A curation needs assessment for the U.S. Army Corps of Engineers found that only five of the sixteen repositories surveyed had a full-time curator for the archaeological collections they housed (Bade and Lueck 1994). In the other eleven, the responsibilities for written policies and procedures; updated, complete, and accessible management records; collections security; a computerized inventory process; artifact accessibility; and periodic inspections either were not done or were divided among staff.

Third, there needs to be much more interaction between archaeologists and repository staff. Archaeologists need to be involved in developing and updating collection management policies because these policies can significantly affect research efforts (Sullivan 1992a, 2001). At the same time, curators need to be involved in the development of archaeological research designs and collecting strategies.

CURATION COSTS

"Until the American public becomes aware that excavation makes up only about a fourth of archaeological research, laboratory analy-

ses and curation the other three quarters, it will be extremely diffi-
cult to acquire the needed support on a continuing basis" (Hester
1977:10). Yes, the public should know how costly curation is since
they are increasingly paying for it with their tax dollars. More im-
portant, however, archaeologists, CRM contractors, and state and
federal agencies must learn the real costs of managing the collections
they either generate or own. The reality is that excavation or survey
involves one-time costs; long-term collections care involves contin-
ued costs (Woosley 1992). Yet it is well known that archaeological re-
search and mitigation work have received considerably more dollars
than curation (Society for American Archaeology [SAA] Curation
Task Force 1993).

The costs of curation have been a major concern for as long as any-
one has spoken up about archaeological collections management in
general. The tremendous influx of new collections in the late 1970s
elevated this concern (Marquardt 1977a; Marquardt et al. 1982;
McGimsey and Davis 1977), further heightened by the curation stan-
dards in 36 CFR Part 79. By one count, the federal standards added
twenty-one new costs to the curation process (Harris 1993), yet most
agencies did not budget for curation, and most repositories did not
have money to increase staff, space, or facilities (Acuff 1993; Bell
1990; Moore 1994). Nevertheless, the significant costs of curating and
making accessible millions of archaeological artifacts, records, and re-
ports are here to stay.

INFORMATION MANAGEMENT SYSTEMS FOR CATALOGS AND INVENTORIES

Accountability of and accessibility to collections are critical to
their long-term care and their use for research, public interpretation,
and exhibit. If we do not know what is in a collection, where its con-
tents are located, when it was last inventoried or inspected, and
where the documents and reports containing essential contextual in-
formation about the collection are located, then it is all rather useless
until found. In fact, why keep a collection at all if it is not known
about or accessible?

Several surveys over the years have assessed the information man-
agement capabilities of U.S. repositories. They found that basic cata-
logs and inventories with locational information have been seriously
deficient or lacking, particularly for federal collections (Ford 1977;

GAO 1987; Lindsay et al. 1980; Meyers and Trimble 1993; Trimble and Meyers 1991). Furthermore, the records of an agency rarely agree with the records of the caretaking repository (Ferguson and Giesen 1999; Moore 1994).

Substandard collections information management persists in many settings even as archaeologists have become computer-savvy. Database technology allows access to a huge range of data, efficient searching and data retrieval, and identification of gaps, biases, and research potential in the data (Sullivan 1992a, 2001; Woosley 1992). Appropriate hardware and staff expertise are not hard to find, although often expensive. There are several software applications for cataloging collections and archives, as well as bibliographical systems for reports (see Toolkit, volume 7). Archaeologists and curators need to work together to maximize the effective use of information management technology.

MANAGEMENT OF ASSOCIATED RECORDS

The condition of artifact collections is widely deficient, but the management of the records pertaining to archaeological investigations and collections is abysmal. Poor records management has led to loss of primary archaeological research data and is leading to loss of data on the history of the discipline.

Records unite the artifacts and specimens with their proveniences, thereby making primary data useful for basic research. Field and laboratory records and project correspondence also contain epistemological information. They show how innovations have been applied to regional archaeology and shaped our current understanding of regional prehistory. Records contain copious information about the interpersonal relations and networks that often lead to use (or dismissal) of certain methods or techniques. They also provide insights into various personalities and their effects on the discipline (Sullivan 1991, 1995).

Four principal problems have been identified in records management. The first is that some archaeologists do not submit complete sets of field records with a collection (Trimble and Meyers 1991). Such collections lack contextual information and are virtually useless.

The second problem lies in recognizing who owns and is responsible for records. The 36 CFR Part 79 regulations have clarified this issue:

- Records related to federal projects are highly valuable and must be kept with an artifact collection.
- A federal agency is responsible for the administrative records regarding disposition and care of their collections.
- A repository is responsible for the long-term care of all the associated records for an artifact collection it curates.

The third problem involves storage practices. Not only are records collections rarely stored in fireproof cabinets, but there has been a tendency to separate the records from the associated artifact collection. Sometimes the documents and artifacts are stored in different buildings or towns (Meyers and Trimble 1993), and sometimes the documents have been destroyed (GAO 1987). In these cases, accessibility to and optimal use of a collection may be severely compromised.

A related matter is the condition of documents as they are stored, both in the field and in the repository. Often, various media of paper, ink, film, and video used to capture key information deteriorate due to unstable or inappropriate environmental conditions. Basic practices must be implemented to save the records:

- Completely inventory the records in a collection.
- Use archival quality paper for copies of documents.
- Separate record copies from originals to ensure preservation while maintaining access.
- Create an archives management plan to set priorities for rehabilitating damaged records.

The final problem involves the increasing creation, use, and reliance on electronic data by archaeologists through word-processed documents, digital photographs, Geographic Information System (GIS) or computer-aided drawing (CAD) data layers, database files, and websites (Carroll 2002). These types of associated records are in many ways more fragile than paper and film. There are some very basic practices that should be applied to ensure the long-term preservation of electronic data. First, at the beginning of a project, archaeologists must carefully plan the types of software and file formats that will be used to ensure compatibility and long-term utility. They also must decide whether it is practical to make paper copies of electronic information. Then, for each electronic file, basic information must be documented, such as format, version of software used,

date of creation, creator's name, file relations, and database structure, and related scripts or macros. Finally, all electronic data must be migrated to up-to-date file formats and software as old software and hardware become obsolete and unusable. The migrations also must be documented. If these basic practices are not followed, important information representing considerable time, costs, and expertise will be lost forever.

NAGPRA AND CONSULTATION WITH AMERICAN INDIANS

The need for guidelines, special considerations, and sensitivity regarding the curation and use of American Indian skeletal remains, associated funerary objects, and sacred objects has been recognized for some time (Lindsay et al. 1980; McGimsey and Davis 1977). It was not until the enactment of NAGPRA in 1990, however, that federal agencies and many repositories were required to do something about it (McKeown et al. 1998). Under the threat of deadlines and fines, the primary needs in recent years have been to

- inventory collections to determine whether they contain human skeletal remains, funerary objects, sacred objects, and objects of cultural patrimony;
- resolve ownership and responsibility for related costs;
- identify and then retrieve skeletal remains on loan;
- consult with tribes about the cultural affiliation of the remains and about repatriation; and
- repatriate requested remains and materials to affiliated tribes.

The NAGPRA inventory process has been time-consuming and costly. For some agencies and repositories, it was the primary focus of staff effort for years and, in some cases, still is.

The net effect of NAGPRA has been positive, although there is still a long way to go. Tribal representatives are now in dialogues with archaeologists, curators, administrators, land managers, state historic preservation officers and staff, and many others who tended not to interact in previous decades. Some tribes have designated their own tribal historic preservation officers. Compromises and agreements are being developed on several curation issues:

- Archaeological research interests versus tribal concerns that may vary by tribe
- Appropriate analytical procedures for different types of objects
- Collections access and use procedures for skeletal remains and for objects related to traditional values and uses
- Collections access and use for traditional rites and ceremonies
- Long-term effects of conservation treatments (Odegaard 2000)

DEACCESSIONING

Deaccessioning is "the process used to remove permanently an object from a museum's collection" (Malaro 1998:217). When 36 CFR Part 79 was issued in 1990, an important section was published "as proposed" only. It concerned the authority and criteria to deaccession individual items or portions of collections. The proposed regulation met opposition from archaeologists who foresaw the development of new analytical techniques to extract important, unanticipated information from existing collections and who emphasize the finite nature of the resources held in repositories (Childs 1999; Sonderman 1996). Also, at a time when very positive steps in collections management were beginning to be made, it did not make sense to appear to promote deaccessioning. Thus, this regulation was not promulgated.

However, the need to be able to deaccession portions of collections is becoming urgent for many archaeologists and curators. Huge amounts of bulk materials such as shell, fire-cracked rock, and unanalyzed soil samples result from archaeological projects, and real limitations exist on storage space and staff to process the materials (Acuff 1993; Bell 1990; Sonderman 1996). Some archaeologists question whether these materials will ever be analyzed. Many are asking, "Why keep all of them?"

Three steps can be taken. First, key professional societies need to make deaccessioning an issue, educate their members about the subject, and become involved in finding and implementing solutions. Many archaeologists do not know what accessioning is, so how can they be expected to know about deaccessioning (Sonderman 1996)?

Second, the National Park Service should revive its effort to publish a deaccessioning regulation under 36 CFR Part 79. It should consider the appropriate conditions under which archaeological collections may be deaccessioned, such as loss, theft or involuntary destruction, abandonment and voluntary destruction, nonconformity

to a repository's scope of collection, destructive analysis, return to rightful owner, and repatriation under NAGPRA. It must also consider particular types of materials, such as those that were inadvertently collected and later determined to lack archaeological or historical significance, are highly redundant and nondiagnostic, are without good research potential, are deemed to lack archaeological interest under ARPA, or are a hazard to human safety and health.

A third step is to involve more archaeologists in writing the deaccessioning policy for the repository with which they work. This interaction may help prevent inappropriate deaccessioning by a repository and facilitate appropriate deaccessioning in consultation with archaeologists. For example, inactive, relatively inaccessible storage may be appropriate for highly redundant, infrequently analyzed materials.

LOOTING OF SITES AND THE ILLICIT TRADE IN ARCHAEOLOGICAL OBJECTS

The looting and destruction of archaeological sites is ultimately about finding collectible objects that can be traded and sold for considerable prices. Many archaeologists focus on rightly condemning the act of looting and the visible effects on sites rather than on the looter's desire for the objects buried in the sites. Professional attention needs to be directed to the types of objects looted from sites, the effects of their loss on the use and interpretation of archaeological collections, and the need for better public education about the critical interrelationships between sites and the objects buried in them. Repositories are increasingly doing their part by accessioning archaeological objects with clear provenience information and improving security to prevent theft of valuable objects.

CERTIFICATION OF REPOSITORIES

A federally funded study promulgated a proposal to certify repositories that meet well-defined standards accompanied recognition of the need for guidelines and standards for long-term collections care (Lindsay et al. 1980), especially for federal collections. The proposal advocated establishment of a task force to set criteria for certification and a coordinating office to authorize accreditation and to monitor the practices of accredited repositories. It also proposed a grant pro-

gram to help repositories improve their facilities and practices to achieve certification.

The regulations in 36 CFR Part 79 did not include any mechanism to certify repositories that met its standards. Although state and federal agencies and private CRM companies often want assurance about the quality of curation services for which they now pay, the issue of an accreditation program at the federal level is in suspension. Such a program is often seen to be too costly and perhaps redundant, especially because the American Association of Museums (AAM) provides accreditation for museums in general. Still, not all repositories are museums, so AAM accreditation is not the answer. On the state level, Texas was the first to initiate a program specifically to accredit repositories curating archaeological collections. The Accreditation and Review Council, a unit of the Council of Texas Archeologists, developed this program (see the appendix for its website address). Perhaps other states will follow this lead if the Texas program proves successful.

NATIONAL INITIATIVE FOR CURATION

The need for a national initiative or system to preserve and protect archaeological collections, records, and reports has been an issue since the 1970s. The focus would be the huge collections owned by federal agencies for the American public and curated by federal and nonfederal repositories. The goals of such an effort would include the following:

- Providing uniform guidance on the deposition, long-term care, and access to collections (partially achieved with the issuance of 36 CFR Part 79) and encouraging state and private groups to use the national standards
- Coordinating policy, guaranteeing consistency in policy implementation, and acting as a clearinghouse for information sharing on archaeological collection management issues
- Conducting a full assessment of the nation's collections by identifying existing repositories and evaluating the conditions of the facilities, information management systems, collections, records, and reports
- Accrediting repositories to participate in the national program and providing oversight and review of repository activities
- Creating a grants program to rehabilitate old collections, upgrade repositories, and improve information management systems

• Coordinating efforts to inventory and index archaeological reports, store and disseminate digital data, and maintain an up-to-date national database of the unpublished, gray literature (Ford 1977; Lindsay et al. 1980; SAA Curation Task Force 1993; Scoville 1977)

This effort could take several forms. It could be fully funded and managed by one federal agency on behalf of all others (Scoville 1977), coordinated by a federal agency with the state historic preservation offices (Lindsay et al. 1980), or managed by an independent, national organization with federal and nonfederal advisers (Lindsay et al. 1980). Each of these has potential problems in terms of organization and infrastructure, funding sources, budgeting priorities, implementation and monitoring responsibilities, and accountability. As a result, relatively little has been done at the national level, although further consideration of such an initiative is important at this time.

THE BRIGHT SIDE

Despite the problems surrounding archaeological collections, records, and reports that still need to be systematically confronted, some notable progress has been made in recent years.

The publication of 36 CFR Part 79 stimulated development and implementation of standards by several federal agencies and many states, including New York (New York Archaeological Council 1994), Maryland (Shaffer and Cole 1994), West Virginia, and Vermont, among many others. Cities with archaeology programs, such as Alexandria, Virginia (Magid 1991), and state/federal research programs, such as the Savannah River Archaeological Research Program (Crass 1991), also have developed curation policies and procedures.

Several important surveys were conducted in the late 1970s and 1980s to determine the status of university, state, and federal collections and repositories across the United States (Ford 1977; GAO 1987; Jelks 1989; Lindsay et al. 1979, 1980). These surveys identified and outlined the curation crisis. More recently, the U.S. Army Corps of Engineers established a Mandatory Center of Expertise in Archaeological Curation and Collections Management, and its assessments of specific collections and facilities have provided a more detailed and vivid picture of the existing deficiencies and problems of federal collections (Bade and Lueck 1994; Meyers and Trimble 1993; Trimble and Meyers 1991). The center assesses groups of collections, sets pri-

orities for resolving the problems, funds required activities, pursues the establishment of state and regional repositories to control costs and maximize accessibility to and use of collections, writes guidelines for field collections and collections management (Griset and Kodack 1999), and helps focus professional attention on curation.

The National Science Foundation's Systematic Anthropological Collections program once provided financial assistance for improving the care and management of significant non-federal collections (Greene 1985), but the program no longer exists. The National Endowment for the Humanities now has two helpful grant programs: "Preserving and Creating Intellectual Access to Collections" provides funding for collections stabilization, storage, and the like; the "Preservation Assistance Grants" provide funding to assess the needs of a repository.

A 1994 survey by the Interagency Federal Collections Working Group helped some federal agencies determine the present locations of their collections in nonfederal repositories and promoted the establishment of formal partnerships between federal agencies and repositories (Childs 1995; Wilson 1999). Three national conferences focused on partnerships for federally associated collections have been held between 1996 and 2000 building on new understandings and issues that resulted from the survey.

Although regional repositories are not popular for organizational reasons, and because many small museums fear that the primary collections under their care will be taken away, some regional repositories have been established for specific government agency collections. These repositories were created either in anticipation of a huge influx of materials or to consolidate collections within a region for better care, access, and use. Examples include the Anasazi Heritage Center in Colorado for the Bureau of Land Management, the Portland, Oregon, district repository and the Illinois State Museum cooperative agreement with the St. Louis District of the U.S. Army Corps of Engineers, and Fort Vancouver in Washington for the National Park Service (Bush 1996; Woosley 1992).

Recent initiatives have heightened interest in the preservation of and accessibility to archaeological records and reports, including field records in all media, laboratory reports and data, oral histories, administrative documents, and correspondence. These records are essential to interpret the archaeological record and to record the history of the discipline (D. Fowler et al. 1996; Silverman and Parezo 1995). A group of anthropologists, archivists, and information managers recently formed

a nonprofit organization called the Council for the Preservation of Anthropological Records (CoPAR). Its goals are to heighten professional awareness of the need to archive personal collections of documents; create research and indexing aids to increase accessibility to archived collections; facilitate repository support; and educate professionals about issues concerning preservation, digitization and information management, and ethics (Fowler et al. 1996). CoPAR has a website to help anthropologists find research materials in archives and learn how to archive their own records (see the appendix).

The National Archeological Database (NADB) has grown in recent years to provide an Internet-accessible, searchable system of information about key documents relevant to archaeologists, curators, and many others (Canouts 1992). The principal module, NADB-Reports, is a bibliographical inventory of hundreds of thousands of archaeological reports, mostly gray literature. The institution that holds a copy of a report is identified during a search of the database. NADB-NAGPRA is a compilation of key NAGPRA documents. Another module, NADB-MAPS, contains GIS maps that show national distributions of cultural and environmental resources. NADB-Permits, an inventory of federal archaeological permits issued between 1908 and 1984, should be available soon.

Another promising development is that in 1999, the Society for American Archaeology (SAA) established a standing committee on the curation of archaeological collections (Childs 2000). Curation issues now have continuing, focused attention from the archaeological profession beyond the Society for Historical Archaeology. The new ethical guidelines for curation (Childs 2002), mentioned earlier, are a product of this committee working in concert with the SAA's Committee on Ethics.

We are still in a curation crisis, but we have made progress. Better education about archaeological collections management, stronger commitment by archaeologists and professional societies to both the making and care of collections, increased numbers of cooperative efforts, and better inventory and cataloging systems will foster even greater progress.

4

REPOSITORIES: WHAT ARE THEY, AND WHAT DO THEY DO?

A repository, "a place to care for collections," is a key concept in this book. This is a facility that holds archaeological collections, associated records, and reports. If properly set up and maintained by its staff, the repository plays the primary role in the long-term stability and usefulness of the materials it holds for research, interpretation, cultural heritage, and public exhibition.

Federal regulations, 36 CFR Part 79, provide another commonly used definition of a repository:

> a facility such as a museum, archeological center, laboratory or storage facility managed by a university, college, museum, other educational or scientific institution, a Federal, State or local Government agency or Indian tribe that can provide professional, systematic and accountable curatorial services on a long-term basis. (National Park Service 1990:37632)

This broad definition recognizes several important aspects of a repository. First, there are several types of repositories across the United States that differ in significant ways. Second, the words *accountable* and *long-term* emphasize the fact that specific curatorial services must be accountable to someone over a long period of time, whether it is a board of directors, contributors to a nonprofit institution, or a federal agency and the taxpayers who support it. Finally, the term *professional* indicates that curatorial work requires professional training and expertise in order to carry out the responsibilities of managing a repository and its contents.

KINDS OF REPOSITORIES

We have grown up hearing the word *museum*, not *repository*. We visit museums, not repositories. Yet archaeological curation centers on repositories. There are several types of repositories across the United States: museums, academic repositories, tribal museums and cultural centers, government repositories, historical societies, and archives. Each type often has a different configuration of missions and goals and an emphasis on a different array of activities. Archaeologists need to understand how repositories differ in order to know how to relate to them (see chapter 7). All repositories should meet a number of common standards in order to provide the best possible long-term care for and management of the collections they contain (see chapter 5).

MUSEUMS

A useful definition of a museum, adapted from the Museum Services Act, is "a permanent, nonprofit organization, essentially educational and often aesthetic in purpose, which, utilizing professional staff, acquires tangible objects, interprets them, cares for them, and exhibits them to the public on a regular basis" (Malaro 1994:81). The key words are *nonprofit* and *educational*. A nonprofit institution benefits the public, usually by providing service(s) to the public (Butler 1989; Malaro 1994). Because benefiting the public is seen as charity, nonprofit museums are exempt from taxes. Museums also can accept tax-deductible contributions from individuals and organizations.

A nonprofit museum can be private or public (Nichols 1989). Private nonprofit museums are founded because one or more individuals donate a collection or collections, or because one or more individuals organize a nonprofit museum around their own collection(s). A museum's mission may or may not involve collecting more objects after it is established. Public nonprofit museums are established by federal, state, or local legislative action when someone donates one or more collections to a public agency or a public agency owns and creates collections. The nature of the collection and the services provided can further define a museum. For example, a natural history museum, regional museum, historical society, and historical museum all may hold archaeological collections.

The primary service a nonprofit museum provides to the public is education, and this service generally distinguishes it from a repository. Usually a museum's statement of purpose clearly states the intended results of educational service, while its mission statement provides the methods, including exhibits and public programs. Education requires an infrastructure with types of expertise other than those required to manage a repository and care for the collections it holds. For example, planning and creating an exhibit requires considerable research on the context of the collection(s) and the individual objects put on display, plus expertise on exhibit construction, a firm understanding of the exhibit's intended audience, and full consideration of security, preservation, and housekeeping issues. Public programs require working with diverse publics, including different age groups, schools, Native American and other cultural groups, and the disabled. It also involves teacher training and expertise in evaluating program effectiveness.

ACADEMIC REPOSITORIES

Secondary schools, institutes, colleges, and universities, as educational institutions, are also nonprofit organizations. Many, too, have repositories under their institutional umbrella. One type of repository is the academic museum. The Peabody Museum of Archaeology and Ethnology at Harvard University, a well-known and well-established academic museum, comes to mind, as does the nearly eponymous R. S. Peabody Museum at Andover Academy, a secondary school. They serve the public by offering exhibits and educational programs yet also are attuned to the research needs of their faculty and students. An important characteristic of this type of museum is accessibility by professionals, students, and other interested individuals, such as Native Americans, to the vast majority of the museum's collections that are behind-the-scenes. Effective accessibility requires up-to-date management of the objects and the associated documentation, a regular inventory system, adequate research space, conservation, security, and fire protection.

Another type of repository in some academic institutions is a place for long-term storage of collections generated by its faculty and students, as well as for research on those collections. Its mission, when stated, does not include public education through exhibits and programs. It fulfills

its basic educational goal when faculty use the repository for teaching and research. This type of repository requires all the features of an academic museum but without public outreach: up-to-date collections management, an inventory system, adequate research space, conservation, security, and fire protection. Unfortunately, some of these features are often not available due to lack of funding and inadequate staffing.

TRIBAL MUSEUMS AND CULTURAL CENTERS

Heightened tribal interests in issues of heritage, identity and community, along with the passage of NAGPRA, have influenced the recent growth of tribal museums and cultural centers. Depending on the tribe, such a facility may be an independent, nonprofit museum with trained museum staff, an institution under the umbrella of a parent organization such as a tribal government, a cultural center, or a mixture of these (e.g., Nason 1999; Warren 1991).

Cultural centers and tribal museums have several primary functions. One is to provide heritage and language education for tribal members, as well as others, from the perspective of the tribe. This often involves using archaeological and ethnographic objects in exhibits and programs including dances, feasts, and craft demonstrations. Another is to appropriately house, care for, and respect human skeletal remains, funerary objects, sacred objects, and objects of cultural patrimony from archaeological projects that are repatriated under NAGPRA, as well as any other stored objects (Jennings 1996). Some outcomes of this function are innovative research and community-based collaboration on new methods to store, handle, and provide access to Native American collections (Nason 1999).

HISTORICAL SOCIETIES

Museums associated with historical societies tend to curate a hodgepodge of collections from a particular geographic area, usually a state or county. Many have a long history, sometimes preceding the well-established public museums. Often they started with gifts of assorted items from local residents in the spirit of documenting and preserving local history. Although well-trained staff support some historical society museums, many others depend on the good intentions of volunteers.

GOVERNMENT REPOSITORIES

Many public agencies generate and own archaeological collections. Recent data from several sources indicate that the federal government alone owns well over sixty million archaeological objects, thousands of cubic feet of objects (this group is counted differently), and thousands more linear feet of associated documentation (Ferguson and Giesen 1999; Wilson 1999). We do not know of any effort to quantify the number or cubic feet of objects owned by states, local governments, or tribes.

Many government-owned collections have been placed in the care of nongovernment museums, both private and academic, for many decades. The latest count of nonfederal museums and repositories holding federal collections for Department of Interior agencies is almost five hundred (Wilson 1999). Many federal and state agencies, however, also have chosen to care for their collections in their own facilities. While the Bureau of Land Management manages only three repositories and relies on 189 nonfederal museums and repositories to care for its collections (Damadio 1999), the National Park Service has over three hundred park and curatorial repositories to hold its museum property, the majority of which is archaeological (NPS 1998).

Like academic repositories, there are primarily two kinds of government repositories for archaeological collections. The first is a museum with a strong emphasis on public education and outreach. Examples are the Florida Museum of Natural History, the Anasazi Heritage Center operated by the Bureau of Land Management, and the visitors' center at Colonial National Historical Park. Because many agencies own and manage archaeological sites, some museums offer both artifact exhibits and visits to the archaeological sites from which they came. These museums also offer access to stored collections. Access usually is regulated to minimize risk to the objects and documents. Given the mission to provide both educational programs and access to the collections, a museum must have staff who can research and build exhibits; teach; catalog, accession, and inventory the collections; ensure security and fire prevention; and provide conservation for objects. It also must have space for researchers, students, individuals whose heritage is tied to the collections, and the interested public to examine and sometimes use the material. Native American groups, in particular, periodically visit public museums that care for objects of particular ritual or spiritual significance in order to perform ceremonies.

The other type of government repository is one that does not have active public outreach and educational activities. Its primary missions are to care for the agency's collections and to provide access to those collections for the same diverse public as the public museums. Some government collections, however, are placed in dead or low-maintenance storage that does not allow for ready access. When objects in this kind of storage are requested, repository staff must retrieve the items and make them available in a location amenable to research or other specified uses. Clearly, if collections are cared for in different storage locations under the management of one repository, the cataloging and accession information must be up-to-date and accurate.

ARCHIVES

Some materials related to archaeology might be cared for in an *archive,* a depository of records (Ellis 1993; Vogt-O'Connor 1999; Wilsted and Nolte 1991). It can hold and conserve key documents that outline the history of an individual archaeologist, the discipline, or a state, federal, or private archaeology program or society. Although many archaeologists deposit their correspondence, miscellaneous field and laboratory records, diaries, draft articles, and other documents in the same repository as the collections they produced, many others do not. The records of government archaeology programs are sent to government archives on a regular basis.

Many archives now manage digitized records, such as computer files of letters, draft articles, GIS maps, and correspondence. E-mail often is never transferred to paper, yet it may contain important facts and observations about an archaeological project or logistical details not recorded elsewhere. Archivists and document conservators must deal with constant, rapid, technological change in order to preserve documents in useable forms (Vogt-O'Connor 1999; Puglia 1999).

WHAT A REPOSITORY DOES AND WHY

Of the various kinds of repositories, museums tend to have the most diverse array of programs, usually geared to a wide audience. Museum programs can include collections care and management, basic and applied research, and public education, including exhibits. Other types of repositories sponsor a more limited range of programs. What follows is

a brief overview of the various kinds of programs in which repositories may be engaged and the rationale or benefits of such programs.

COLLECTIONS MANAGEMENT

All repositories have collections care and management programs. These programs are the heart of the institutions and are what make them repositories. Collections programs tend to be the activities archaeologists most directly equate with curation. As we note, however, a museum curator may be primarily responsible for research and educational programs, while collections care may be the duty of other professional staff. In larger repositories, collections care can be the responsibility of several staff members with different training. In a small institution, one staff member may be required to be a jack-of-all-trades in regard to collections.

Managing and caring for collections in accordance with a repository's mission require work on the physical well-being, overall coherence and composition, and safety of collection items as well as their accessibility. *Conservation* is the care of the physical condition of collections. Environmental conditions, storage furniture and containers, and treatments to stabilize or repair deteriorating or damaged materials all are aspects of collections conservation.

Accessibility of collections refers to how readily collections and information can be found and used. Access to collections in repositories may be necessary for research, programming, heritage or religious purposes, or collections conservation, such as monitoring fragile materials.

Computerized inventories are nearly indispensable for keeping track of items, their storage locations, and relevant documentation. Electronic databases eliminate the need for the card catalogs that used to be the mainstays of library and museum collections management. Managing the content of a repository's collections is an intellectual endeavor with the goal of matching objects to the repository's overall mission and subject matter theme(s). For example, an institution that curates archaeological materials most likely has a defined geographic area(s) from which it will acquire such materials.

Different kinds of repositories can have differing goals for their collections programs, depending on their institutional contexts and missions. The collections of a museum, for example, are intended for public benefit and may include more items suitable for exhibition

and public education than collections curated by a university anthropology department. The latter repository likely houses the products of faculty research, which may be used for teaching and research, but not often for exhibition.

A repository must have policies, procedures, and plans that are broad enough to cover all of the kinds of materials it curates. Archaeological materials may be only one category of collections managed by a repository. Natural history or general museums, for example, often curate geological and paleontological collections including gems and minerals, fossils, and core samples; decorative arts and historical items such as costumes, furniture, toys, photographs, and paintings; biological specimens including herbaria, animal skins, feathers, and taxidermy collections; and ethnographic items such as baskets, masks, spears, and clothing. The wider the range of items a repository curates, the more complex are the issues of collections care and management. More specialized knowledge is necessary to care for the collections. For example, environmental controls for herbarium collections can be quite different from those for gems and minerals. It is unrealistic to expect a professional staff member such as a conservator, who is trained to care for the physical well-being of many different kinds of materials and objects, to be well versed in the subject matter and research issues of a particular discipline.

EDUCATIONAL PROGRAMS AND EXHIBITS

Although the purpose of all repositories is at least indirectly related to education and learning through the collections they curate, not all repositories sponsor direct programming in the form of exhibits, lectures, workshops, field trips, and the like. The content of educational programs usually is connected to the repository's mission and to the subject matter of its collections. A repository can share the educational value and significance of its collections with a broad audience through public programs. Although this is a laudable and worthy goal, especially for publicly owned repositories, there is a danger that public programming can become the cart that drives the horse: collections care can become a secondary activity in terms of funding, visibility, and stature within the institution. The use of collections objects for exhibition and other public programming can present a risk to the objects, a risk that must be managed by the repository. Collections care often must compete with high-profile programs,

such as blockbuster exhibits, for institutional resources and support. In some cases, however, such public programming is beneficial to collections care because it can generate funding.

RESEARCH

Research in the context of a repository may take several forms and may be basic or applied. Basic research generally is oriented toward creating new knowledge purely for the sake of learning, while applied research generally takes existing information and uses it to solve a problem or create a new application such as an exhibit or other program. Repositories such as large natural history museums may have their own staff members who are involved in basic research and who do fieldwork that adds to the repository's collections. In-house and other research staff members do basic research involving existing collections. Smaller repositories that do public programs may have staff members who do applied research, but the staff members of repositories not involved in public programming may have no research duties whatsoever in the disciplines of the collections. They may, however, be involved in research oriented toward collections care, such as discovering new ways to treat and preserve certain material types.

Like the kinds of collections it acquires, the kinds of research a repository conducts are tied to its mission and to the size and training level of its staff. In the tight-budget environments of many museums, staff members who care for and manage collections often are viewed as infrastructure, while those who do basic research more likely are considered to be a luxury. As noted in chapter 2, this was not the case in the nineteenth century when museum research staffs were needed to build collections, before academia took primary responsibility for basic research from museums. Today, with most archaeological collections made by archaeologists not associated with repositories, the need for repositories to have their own field research staff is becoming less crucial to many repository administrators.

RESPONSIBILITIES AND TRAINING
OF REPOSITORY STAFF

Staffing of a repository largely is a function of its size, mission, and funding. Not surprisingly, larger repositories generally have broader

missions and larger funding bases, so they tend to have the largest and most diverse staffs. Curatorial staff tend to be specialized and to have more focused responsibilities in large institutions. Staff in smaller institutions tend to be the "general practitioners" of curation, calling in specialists as consultants for specific needs. Archaeologists often use the term *curator* to refer to all professional staff members that are involved with collections in a repository. The responsibilities of curators may be quite different depending on the institutional context.

CURATORS, CONSERVATORS, REGISTRARS, AND COLLECTIONS MANAGERS: WHAT ARE THEY?

The management and care of collections has become more professionalized and more complex. The greater amounts of information, legalities, and public accountability associated with curatorial work all have contributed to the needs for increased specialization and training of repository staff. Museum studies programs at some universities (e.g., Texas Tech and George Washington University) train students specifically for jobs in collections care and management.

Table 4.1 summarizes characteristic positions, responsibilities, and training for the various kinds of curatorial staff. In some large museums or repositories, collections staff may belong to an administratively separate division distinct from research staff. In such settings, research staff members may have the title of curator yet may have little responsibility for collections management or care (the Peabody Museum of Archaeology and Ethnography at Harvard has this kind of administrative structure). Archaeologists working with repositories through curation agreements or collections research most typically deal with either collections managers or curators (M. E. King 1980; Terrell 1979). A registrar (Buck and Gilmore 1998) also may be involved if collections are to be loaned or exhibited because registrars handle risk management and insurance considerations.

A collections manager typically holds a master's degree and has experience in the discipline of the collection. An archaeology collections manager, for example, typically will have some archaeological field experience and will have taken museum studies courses in school or classes offered by institutes such as the Campbell Center in Mount Carroll, Illinois. A collections manager usually has some knowledge of the discipline but typically is not engaged in a program of basic research. Collections managers generally are trained to know

Table 4.1.	Curation-Related Jobs	
Job Title	*Duties*	*Training*
Registrar	Generally responsible for collections inventory, tracking, and risk management. Coordinates overall planning for collections needs.	Master's degree in museum studies or related field; computer expertise (especially database programs)
Collections manager	Responsible for day-to-day care of collections, and collections access. Advises on use of collections in exhibits, arranges loans, monitors storage conditions, routine maintenance of collections. May be responsible for certain aspects of cataloging. May write grants for collections care.	Master's degree in museum studies or field of collection; specific training and experience in collections management. Computer experience useful.
Curator	Largely dependent on size of institution. In small institutions, the curator often performs a combination of registrar, collections manager, and curator duties. In large institutions, the curator is a professional in a specific academic discipline and may be responsible for overall administration of a specific collection, research in the discipline of the collection, and/or providing expertise in that discipline for other museum programs. Writes grant applications for research, collections care, and/or exhibitions.	In a small institution, a master's degree in museum studies or a discipline relevant to the museum's collections and museum experience. In a large institution or one with large, specialized collections, a Ph.D. in the specialty for the collection being curated. Museum experience is helpful. Otherwise similar credentials as for academic jobs, although teaching experience is not critical.
Conservator	Cares for the physical condition of objects in museum collections. May write grants for collections care.	Master's degree in conservation. Requires special training in care and restoration of specific kinds of materials. Involves artistic skills and knowledge of materials analysis/chemistry.
Technician	Prepares collections for study and storage (washes, cleans, numbers, packs, etc.). Assists with field collecting.	B.A. in field of collection. Laboratory and field experience. Organizational skills.
Archivist	Appraises usefulness of records, organizes and culls accordingly so as to preserve accessibility, and preserves physical integrity. Provides for outreach through publications, exhibits, and other visible displays and applications for records.	Master's degree typically in history or library science, but degree in subject matter of records specialization is preferred, as well as specific training in archival techniques. May have Ph.D. in large, specialized institution.

more about the issues, problems, and procedures of managing and caring for collections than most archaeologists.

Repositories having only one staff member who is responsible for the collections typically call this person the curator. In larger institutions with full-time collections managers, curators may be research staff, administrators, or a combination. Such curators are experts in their disciplines and typically hold a Ph.D. Curators' research duties may include applied as well as basic research. Applied research usually involves providing content information and expertise for exhibitions ("curating" exhibits) and other public programs. A curator also may oversee a collection in his or her discipline and may supervise a collections manager who provides the day-to-day collections care and access for users. If a curator is administratively in charge of a collection, she or he also may have considerable influence on the kinds of materials that the repository acquires, but approval of acquisitions usually requires higher-level administrative sanction, such as from a board of trustees.

Many repositories do not have in-house conservators and instead hire highly trained professionals as consultants on an as-needed basis. Yet without in-house conservation expertise, it is difficult to maintain a program of physical collections care. Instead, conservation becomes a special project. Many archaeologists do not realize that the need for conservation expertise is not limited to the repository. Advice from a professional conservator on handling items in the field can be essential for preserving and stabilizing fragile items. Conservators tend to specialize in specific types of materials.

Even fewer repositories have professional archivists on staff, and communication between archaeologists and archivists has been minimal at best. Nonetheless, the importance of records in archaeological collections indicates, minimally, the need for advice from archivists for preserving these materials. Archivists have standards for their training developed by the Society of American Archivists, and, like conservators, archivists tend to specialize in certain subject areas and types of records. More and more archivists are developing expertise in the long-term management of electronic records.

Curatorial support staff may have many different titles; technician is a common one. They do the grunt work of collections care—the time-consuming tasks of cleaning, cataloging, and packing materials, similar to basic archaeological laboratory work. In a university setting, students may provide the labor pool for such duties. In other

contexts, such staff may be full-time or temporary and funded by either "hard" or "soft" money.

CONCLUSION

Differing management contexts and structures affect repository activities, their perceived audiences, and their realms of accountability. The duties and responsibilities of a repository's staff relate to the institution's mission, size, and institutional context. The management structure in which curatorial staff members work differs among repositories and affects how decisions about collections issues relate to decisions concerning archaeological research. The staff members who care for archaeological collections may not themselves be trained archaeologists. Nonetheless, curatorial staff may have professional training and expertise useful to archaeologists and important for the proper care and preservation of collections. Training and expertise in both archaeology and collections management are essential for the effective curation of archaeological collections.

5

MANAGING CURATED
COLLECTIONS: THE BASICS

Few archaeologists have formal training in managing collections. Courses in collections management more typically are taught in museum studies programs than in university anthropology departments. Even when anthropology departments offer courses in museum work, these classes tend to focus on developing exhibits rather than on managing collections. Although archaeologists do not need to become experts in collections management, a working knowledge of basic principles, issues, and terminology is useful for enjoying effective communication with repository staffs and for being sensitive to their concerns, policies, and procedures.

This chapter offers an introduction to the mechanics of collections management. It begins with the entry of items into the repository and ends with use of curated collections by repository patrons. We discuss the policies and procedures repositories use to acquire collections, conduct initial processing and storage, preserve the physical integrity of the objects, maintain accessibility and inventory control, deaccession objects, and enable public use. In the museum world, these policies and procedures generally fall under the rubric of *registration methods* and may be handled by a staff member called a *registrar* (Buck and Gilmore 1998). Repositories differ in the specifics of managing collections, but all face similar challenges and thus have collections management programs that generally are similar.

ACQUISITIONS POLICIES AND PRACTICES

Repositories use the term *acquisition* to refer to the process of obtaining legal title to an object or collection of objects and formally adding it (or them) to the collections. Legal title is obtained through a *transfer of title*, which is the formal process of a change of ownership of an object from one person or organization to another (Malaro 1994). To transfer title, a *deed of gift* often is the contractual statement that must be signed by the appropriate parties, typically the owner of the object(s) and a repository representative. Examples of typical deed of gift forms can be found on several websites (see the appendix). Repositories do not like to acquire objects if there is any doubt about the vendor's or donor's rights of ownership because investment in the care of an object is not prudent if the object's owner can take it from the repository at any time. Questionable acquisition also may violate laws, such as the Archaeological Resources Protection Act (ARPA), that deal with the illicit trade of antiquities, as well as professional museum and archaeological ethics. When public money is used to care for privately owned items, these issues especially are problematic. Archaeologists need to make every effort to ascertain the ownership of collections and to transfer legal title to the repository or appropriate public agency.

A written transfer of title from a private landowner is preferred because a verbal agreement is difficult to document. Repositories often can assist with obtaining title from a recalcitrant private landowner because the public generally views repositories (especially museums) as desirable institutions. On the other hand, the contract archaeologist may be unsuccessful in obtaining title to collections because she or he may be associated with a project that the landowner did not want to occur. ARPA permits should specify repositories for federally owned collections. The contract archaeologist will need to consult with repository staff about policies relevant to curating federal collections because the repository will not actually acquire such materials. Federal and other government collections remain the property of the public entity.

Repositories have policies covering the acquisition of objects. An *acquisition policy* typically includes the following:

- A collecting policy governing what is acquired, aligning the composition of the collections with the institutional mission
- An authorization policy for agreeing to acquisitions, specifying who has the authority to accept materials on behalf of the repository

- A statement of the terms and conditions under which objects will normally be acquired
- Guidelines for determining costs for additional processing, storage, transport, and conservation (what these may cost the repository if the collection is acquired), as well as to what extent the repository will provide or arrange for such services

The governing board of a repository most often approves acquisitions, because this board is legally responsible for the repository's activities (Malaro 1998). Staff members usually are responsible for recommending acquisitions to the board. Beyond the "fit" of a particular collection with a repository's collecting policy, factors that can influence a repository's decision to acquire collections can include the amount of time and money that will be required to process, conserve, and store the objects. An ethic of the museum profession is that collections should not be acquired unless the institution can properly care for them.

ACCESSIONING

Once a repository acquires an object or collection, its formal inclusion into the institution's collections is called *accessioning* (Carnell and Buck 1998). This process follows the transfer of title and includes assigning an accession number and entry of information about the acquired object or collection into the accessions register. An accession file that contains records about the acquisition also typically is developed as part of the accessioning procedure.

A repository that agrees to care for a federal or state collection in perpetuity does not gain title of ownership to that collection unless a transfer of title is completed. Nevertheless, a repository will usually go through the accessioning procedure for those collections to optimize their long-term care.

The typical steps for accessioning a collection or object are these:

1. Evaluate and authorize an acquisition according to agreed museum policy and retain written documentation of this process.
2. Ensure that the receipt of the object is properly planned for and that appropriate long-term storage or display space is available for the object(s) to be acquired.
3. Complete a *condition report* for the object(s) to be acquired (a condition report is a brief description of the physical condition of the

objects in order to highlight any hidden costs of conservation that can be planned for or avoided).
4. Obtain unambiguous evidence of title to the object.
5. Describe the method of acquisition (e.g., bequest, field collection, gift).
6. Assign a unique number to the object or collection.
7. Record the information about the acquisition in the accessions register.

Each repository keeps an *accessions register* as a permanent record of all objects that are or have been part of the institution's collections. Entries in the accessions register include the accession number, a brief description of the object or collection, and the date of accession. An accessions register may be handwritten, generated from computer records, or a computer database. Repositories ideally should keep a copy of their accessions register in a secure place, such as microfiche or digital copies held at an outside location.

All of the documents compiled for acquisition of objects and associated records during the accessioning process are called *accession records*. These records provide written evidence of the original title to an object and the transfer of the title to the acquiring institution, and they contain a unique number (accession number) that is physically associated with all objects in an acquisition. Because they describe all acquisitions and list them by number, accession records ensure that an accessions register is maintained and information about the acquisition process is retained. Accession records also are the central place where all subsequent information about a collection's history may be maintained or cross-referenced, such as loans and conservation treatments.

Repositories generally use one of two systems for *accession numbers*. The first assigns a separate number to each item, while the second assigns the same number to all items in one accession group or individual collection and then a suffix to create a unique identity number. The second system works best for archaeological collections, which typically include many small objects. Accession numbers may take the form of a simple running sequence (e.g., 14603; 14604; 14605) or the year of accession followed by a running number (e.g., 1991.3; 1991.4; 1991.5). Identity numbers follow the accession number and may be assigned during the cataloging process. Actual placement of numbers on objects is discussed later in the section on collections preparation.

CATALOGING

Cataloging is the assembly of all primary information about each item in the collection. Archaeologists sometimes confuse cataloging with analysis, although if an object is analyzed as a single item, it usually should be cataloged as a single item. For an archaeological collection, the most important aspect of cataloging is permanently associating a specimen with its archaeological context or provenience. This correlation usually is done as part of typical archaeological laboratory procedures and involves keying a number that is associated with the specimen to a written record of its provenience. Cataloging should be done by, or under the supervision of, someone with subject knowledge as well as familiarity with the cataloging system used by the repository that will curate the collection.

The main purpose of cataloging is to identify and document an object or group of like objects, especially to collect information that is likely to be valuable as an index heading or computerized search term. Such information may include an object's identification number or code and its provenience. While the purpose of cataloging is not to record attributes or collect data for research purposes, catalog information is essential and useful for the research process. Cataloging allows the researcher to know what objects are in a collection, and the identifications made for cataloging purposes often can be used for very general analyses (e.g., sherd counts). Until it is cataloged, an item cannot be indexed properly and will not be easily accessible to museum staff or the public. A repository may also catalog the records associated with an archaeological collection, although repositories handle these records in different ways. A common way is to link the accession number to both the specimens and the records that comprise an individual archaeological collection.

There are no standards for cataloging archaeological collections used by repositories across the United States. Some federal and state repositories have clear policies and guidelines for cataloging (e.g., Department of the Interior 1997). Most repositories commonly collect the following types of information: accession number, catalog number, object name or description, material type, form, quantity, measurements, weight, cataloger name, cataloging date, location in repository, site number, state site number, provenience or collection unit, state, county, Universal Transverse Mercator (UTM) coordinates or township/range/section, field collector, date collected, and conservation and treatment comments (Griset and Kodack 1999).

Catalog or *identity numbers* provide a code for uniquely identifying objects and for linking archaeological objects to their provenience. The form they take varies among repositories, depending on individual needs and past practice. The accession number may serve as the identity number if different accession numbers are given to each item. Otherwise, an item suffix must be added to create a unique identity number. For example, a group of four projectile points brought into the museum together might be accessioned as 1991.24. Each individual point would then be numbered 1991.24.1, 1991.24.2, 1991.24.3, and 1991.24.4. Another common archaeological numbering practice is to use the tripartite Smithsonian site number (i.e., state number/county abbreviation/site number) in lieu of an accession number, but in combination with identity numbers—for example:

$$\frac{11Ms38}{15} \text{ or } \frac{40Mg31}{123}$$

A problem with this system arises when multiple investigations are conducted at the same site because there is no unique designation for the year of investigation. Collections made in different years and by different investigators thus could have objects with identical numbers. This situation should be avoided because it can cause confusion between discrete collections and lead to loss of provenience data. Therefore, a unique set of catalog numbers should be used for each phase of an investigation at a particular site.

Sometimes repositories have to work with numbering systems that they have not created. For example, a collection generated by an amateur archaeologist may already have its own numbering system. These numbers must be preserved as a link to the original records, but they can play havoc with computerized data management systems if they use a different format from the numbering system used by the repository.

COLLECTIONS PREPARATION: LABELING AND CONSERVATION

After objects are cataloged, they must be prepared for storage and for possible research, exhibit, and loans. The primary objectives of collections preparation are to preserve objects and associated records in a stable condition for the long term and to maintain their research,

heritage, and educational values (Jacobson 1998). The latter requires that any action applied to a collection

- be reversible;
- be well documented;
- be respectful of the object's integrity and of the culture from which it originated and is affiliated;
- utilize nonreactive materials; and
- always maintain the connection between the object and its documentation.

A critical step during collections preparation is to *label* or mark each accessioned item or, where appropriate, group of items with its permanent identity number (Segal 1998). Labeling should use methods and materials that do not damage the object and its surface yet ensure that the labels cannot be removed accidentally. Label placement should not negatively affect the appearance of an object or its detail yet must be sufficiently visible to minimize the need to handle the object. It should not be placed in areas that might receive wear or friction, including the bottom of objects. The materials used for labeling should be reversible so they can be removed intentionally with minimal trace, even after fifty to one hundred years. They should have good aging properties and be as chemically stable as possible yet be safe for staff use without posing health risks.

Many factors influence the choice of the most appropriate labeling technique for a specific object. Most factors are closely related to the object's constituent materials and to the physical stability and roughness of the object's surface, the object's porosity, physical strength, and flexibility (Segal 1998; Sease 1994).

Taking into account the basic principles and limitations of labeling, most repositories choose to use semipermanent methods and materials to label their collections. Procedures generally involve thorough examination of the object, cleaning the surface where it is to be marked, applying a base coat of clear, reversible varnish, writing the number on the base coat with a permanent pigment-based ink or acrylic paint, and placing a thin coat of clear varnish over the number. Sufficient drying time must be allowed for each coat. For paper and photographs, writing the number in the same location in pencil is optimal. Repositories may use temporary labeling methods and materials (e.g., attachable tags, outside labels on storage boxes, loose labels) for archaeological objects or records. These are used only for

highly unstable items, temporary deposits, loans, tiny objects, and objects stored outdoors.

For archaeological objects whose research value depends on their link to provenience, some repositories choose to use more permanent marking methods and materials. These procedures may help ensure that the label is not damaged or lost over time, although the semipermanent techniques are often adequate. It is important to consult with a conservator if there is any doubt about appropriate methods and materials. It also is critical to know what materials are *not* good to use for labels, primarily due to their effects over time as summarized in the list below (Segal 1998; Sease 1994):

- Typewriter correction fluids can flake and may resist solvents.
- Nail polish made of cellulose nitrate can yellow, shrink, peel, and become brittle.
- Nail polish remover often contains contaminants other than the solvent.
- Rubber cement adhesive can deteriorate, and it can stain organics.
- Pressure-sensitive tape or label adhesive can deteriorate.
- Paper labels moistened by water are often hard to remove and can stain.
- Ballpoint ink may fade, smear, and resist solvents.
- Metal fasteners and metal-edged tags can corrode, stain, abrade, and cause cracking of some materials.

The other task that is critical to collections preparation involves *condition assessment* and *conservation*. As we discuss in chapter 6, the condition of objects and conservation must be considered during project design, in the field, and in the laboratory. Once in the repository, an assessment is necessary to document the current condition of an object or record and to recommend necessary conservation treatment. The goal of conservation, then, is to maintain the preservation and survival of an object or record in its original state, to the extent possible, often through the use of interventions such as physical strengthening or chemical stabilization.

Conservation may be costly, particularly for submerged or underwater archaeology, and should be carefully budgeted. Conservation also should be a collaborative process that involves archaeologists, collections managers or registrars, curators, and conservators (Cronyn 1990). However, treatment requires the expertise and experience of a conservator who is familiar with the best interventions or treatment

available for the particular constituent materials of an object. All decisions and interventions must be well documented.

STORAGE

Integral to the long-term care and preservation of collections is how they are stored (Ford 1980). *Storage* refers to both the overall conditions of the spaces where collections are kept and the safekeeping of individual objects and associated records (Swain 1998; Department of the Interior 1997).

Collections storage within a repository requires attention to spatial layout, environmental controls for different types of collections, security, fire protection, and disaster planning (table 5.1). Many repositories have areas for long-term storage that are separate from other key activities, such as exhibits, exhibit preparation, research, temporary storage, object preparation, and administration. Such physical separation enhances security as well as protection from fire and other disasters. Some repositories have off-site storage, but this alternative can hinder access, security, and monitoring.

Maintaining environmental standards minimizes the rate of deterioration, extends the lives of objects and records, and reduces the need for conservation treatment. Extreme levels and significant fluctuations in temperature and humidity may damage archaeological objects, especially those made of unstable materials such as metal or wood, bone, and other organics. They also can severely affect documents, photographs, electronic media, and audiovisual recordings. Therefore, temperature and humidity should be monitored and recorded and kept within acceptable ranges. Establishing an appropriate range of relative humidity (RH) involves consideration of local climate, the collection materials and their condition, mold growth prevention, repository structure and layout, and the RH levels to which the collection had been adapted.

Other environmental conditions that require consideration are visible light, ultraviolet radiation (i.e., sunlight), pollutants, and pests. In general, no visible light should be present in a storage area except for short periods of time. Ultraviolet light (UV) should be monitored periodically and controlled with filters if found to be excessive. UV can be particularly harmful to photographs. Gaseous and particulate pollution (e.g., dust, chemical off-gassing from unsealed wooden shelving, solvents, and acidic paper) should be monitored and controlled

Table 5.1. Basic Standards of Repositories

Environmental Controls
- Temperature and humidity
- Level and duration of visible light
- Ultraviolet radiation
- Pests
- Air pollution

Security
- Mechanical and/or electrical system for detecting and deterring intruders
- Policy on access to collections and associated documents, including systems for visitor and researcher registration, opening and closing storage and exhibition areas, and control of keys to particular areas of the repository

Fire Protection
- Fire detection and suppression equipment appropriate for the collections housed in storage and exhibition areas
- Storage of repository and collection records in appropriate fire-resistant container that is also locked when not in use
- Fire plan for the needs of the collections to prevent, detect, and suppress fire

Housekeeping
- Regular cleaning of storage and exhibit spaces based on established procedures and policy
- Maintenance and calibration of monitoring equipment

Physical Examination and Inventory
- Regular examination to detect deterioration of collections' contents
- Inventory policy to regularly confirm locations of collections and prevent loss or theft

Conservation
- Maintenance of objects in stable condition using professional conservation standards and practices

Disaster Planning
- Procedures to protect collections in the event of a natural or human-inflicted disaster

Exhibition
- Consideration of how to best preserve, protect, and minimize risk to objects when planning an exhibit
- Design and use exhibit cases and areas to promote security, housekeeping, and preservation of objects

when appropriate. A rigorous pest management program should be developed because rodents and insects can severely damage organic objects and archival materials. Many repositories have an integrated pest management program to monitor and treat pest infiltration (Jessup 1995).

Individual objects and associated records are packed and housed in an *artifact container* (e.g., bag or box) and then a *storage container*

(e.g., box, larger bag, cabinet, or drawer). Two critical principles must be followed in all storage decision making. First, *provenience information must be maintained at all times*. Provenience labels must be placed on all containers so that their contents can be reunited if they become separated. Second, *all storage materials must be archival quality for long-term use*.

Several factors must be considered when deciding how to store objects and records. One is the frequency of use of the items. If an object is a type specimen that may be regularly studied or used, it is more appropriate to place it in a drawer rather than a box on a high shelf. Another factor is the diversity of materials in the collection. In general, objects and associated records are stored in artifact containers by material class: All the shells from one provenience should be in one bag, all the ceramics in another, and all the photographs in acid-free or inert plastic photographic sleeves. Objects and associated records, particularly those that are fragile or made of unstable materials that require special environmental conditions, should be separated by both artifact container and storage container. Another consideration is the size and weight of the objects. Obviously, a large mortar and pestle should not be placed in the same bag as obsidian flakes, nor should a bag containing a large mortar and pestle be placed in the same storage container as a bag of thin-walled pottery sherds. Some oddly shaped or fragile items may need special support mechanisms to prevent them from further deterioration or to enhance their visibility so as to decrease handling.

Storage of human remains and objects held sacred by various groups require additional considerations. Human remains must be handled with respect and stored in a separate area. The Native American Graves Protection and Repatriation Act of 1990 (NAGPRA) also requires that culturally affiliated, federally recognized American Indian tribes be consulted about the disposition of any remains, as well as sacred objects and objects of cultural patrimony. Therefore, these items should be accessible for consultation. Tribal members also may want to conduct ceremonies in the storage area for various purposes (McKeown et al. 1998).

The most common and suitable artifact container for most objects is the polyethylene zip-top plastic bag. It is easy to handle, lightweight, and economical and can be directly labeled. Bag thickness, no less than two millimeters, is important for long-term curation of the objects inside. Most bags should be perforated with small holes to promote air circulation and prevent the creation of

microenvironments that promote mold. Bags containing objects that are sensitive to the environment, such as iron, should not be perforated (Vogt O'Connor 1996).

Care of records even from a single archaeological project is not a simple task due to the wide variety of formats and media used. The Chickamauga Basin case study we discussed in chapter 2 provides an example. Records from this project include handwritten field notes on notebook paper, standardized mimeographed field and laboratory forms that are filled out with typing and handwriting in ink and pencil, artifact catalog cards on 3 × 5–inch card stock, analytical notes and tallies that are either typed or handwritten on ledger paper, photographs and negatives (the latter of which are typical of the time period with self-destructing silver nitrate), artifact illustrations on vellum, large excavation plats on graph paper, progress reports and preliminary site reports, and correspondence (both typed and handwritten) between the various investigators and with the WPA. To maintain the rich research potential of the collections, these critical and often fragile documents must be carefully preserved.

Appropriate document containers vary by document format and size. Paper records may be contained in acid-free or buffered folders or files or in polypropylene, polyethylene, or polyester sleeves. Each map should be stored in an acid-free folder, although a divider sheet of acid-free tissue between multiple maps is minimally acceptable when expense is a significant issue. Photographs (print, negative, and transparency) should be placed in individual envelopes or sleeves made of acid-free paper or an inert plastic of polypropylene, polyethylene, or polyester. Older nitrate-based negatives can be considered hazardous materials as they deteriorate. Freezing can deter total degradation. The long-term solution is to make copies of all of these negatives. Audio- and videotapes should be stored in acid-free boxes of suitable sizes, while electronic records can be placed in appropriate plastic containers. Tapes and disks should be stored in areas free from harmful electromagnetic fields.

Unacceptable containers for objects include lightweight sandwich and food storage bags, brown paper bags, cigar boxes, plastic (not polyethylene) film vials, and glass containers that are not well insulated and may break. It is also unacceptable to use rubber bands, twist ties, adhesive tape, string, staples, or heat sealing to close artifact containers.

Storage containers, the larger boxes or polyethylene bags that contain one or more smaller artifact containers, should be made of

archivally stable materials. They should also be of standard sizes for optimal stacking on shelves. Repositories vary in their box size requirements, although boxes of approximately one cubic foot are most common for objects.

INVENTORY CONTROL AND DATA MANAGEMENT

An *inventory* document is a permanent record of the physical location of all accessioned and cataloged objects and associated records. It is periodically updated during the process of *inventorying* when the physical locations of items are checked against the list of objects. The inventory process also enables an inspection of the condition of each object and document, and it identifies items that may be lost, missing, or stolen.

An inventory thus is an important means of accounting for and managing data on collections (Malaro 1998; Cowan 1998). At its most basic level, it documents what a repository has and where to find it. It can also relate to other important information critical to the mission of a repository. For federal and state agencies that depend on nonfederal and nonstate repositories to care for their collections, inventories provide a critical check on their property, helping fulfill ethical and legal obligations. It is for these reasons that 36 CFR Part 79.11 specifies periodic inventories and inspections of federal collections. For bureaus with the Department of the Interior, for example, a 100 percent inventory and inspection of all museum property above a certain value and a random sample inventory of all other cataloged items must be done on an annual basis (Department of Interior 1997). A well-documented inventory also is essential for complying with requirements of NAGPRA (McKeown et al. 1998).

A repository benefits from inventory control and good data management. Good location and description information not only enhances security, it also facilitates tracing lost, stolen, or missing objects. When such information is cross-referenced to title, it may further enhance retrieval and help resolve disputes about legal ownership. Accounting for collections increases the repository's credibility in the eyes of funding agencies, potential donors, and the general public. Also, inventories facilitate access to specific items by repository staff, researchers, and educators; access to information about the contents of collections; and data needed for planning and budgeting exhibits and educational programs.

DEACCESSIONING

Despite the claims that all archaeological collections should be preserved in perpetuity for their present and future research value and potential (see chapter 3), there are times when a collection or specific objects may legitimately be deaccessioned (Childs 1999). *Deaccessioning* is "the process used to remove permanently an object from a museum's collection" (Malaro 1998:217). The decision-making process is usually lengthy and well documented because deaccessions often have been controversial. Critics include local communities who felt their cultural heritage was being discarded, donors offended that their gifts were no longer worthwhile, and various support groups who disapproved of how the repository spent auction proceeds (e.g., *not* for new acquisitions). Once a decision is made to deaccession one or more objects, the subsequent action of removal from the repository is *disposal* (Morris 1998).

The primary reasons to deaccession and dispose of archaeological objects are when they are

- outside the repository's scope of collections (see chapter 4),
- subject to repatriation under NAGPRA (see chapter 3),
- physically deteriorated beyond viable research or educational value,
- hazardous,
- incapable of being adequately cared for by the repository, or
- determined to have been acquired illegally or unethically.

The decision to deaccession involves a number of steps (Morris 1998):

- Initiation of action with a written justification that lays out the reason to deaccession in relation to the repository's mission, collecting plan, scope of collections, and any relevant federal or state laws
- Confirmation that the object(s) was accessioned, cataloged, and well documented—a good deaccessioning policy is intimately related to a good accessions policy (Malaro 1998)
- Physical inspection by a conservator to help identify the best method of disposal
- Confirmation of title and a check of the records for any donor restrictions
- When applicable, an outside appraisal of the monetary and research value

- Internal review to ensure full knowledge of the deaccessioning plan
- Approval by the repository director and governing board, and review committee, if established
- Assignment of a deaccession number to each item to be disposed of
- Public relations, particularly with local community groups whose cultural heritage may be the subject of deaccessioning and disposal

The final act of the deaccessioning process is disposal. There are several options for archaeological objects, although every effort should be made to transfer, through donation or exchange, the objects to another repository in the vicinity for research and educational use. The primary means of disposition are as follows:

- Donation and transfer of title to another repository to maintain educational use.
- Repatriation (the restoration of control over) of human remains, funerary objects, sacred objects, and objects of cultural patrimony to affiliated Native American tribes, other appropriate culture groups, or countries of origin. Packing and delivery of repatriated objects should be done in consultation with the recipient group in order to respect traditional practices and beliefs (McKeown et al. 1998).
- Exchange with other repositories, usually of items of equal value and significance. This involves transfer of title.
- Physical destruction. This disposal technique may be applied to hazardous items, severely deteriorated items, and counterfeits. The exact method chosen should be permanent, irreversible, and well documented. Destructive analysis for research purposes, when total, is often placed in this category.
- Return to rightful owner if it is determined that the donor was not the legal owner.
- Public auction, usually to raise funds for future acquisitions. This option usually is not appropriate for archaeological items recovered in a research or CRM context for ethical reasons.

PUBLIC ACCESS AND USE

Use of collections is both a bane and a blessing for repositories. The purpose of having collections is to use them. However, their use puts them at risk because individual items may accidentally become dam-

aged, proveniences can get lost if objects are not labeled, and a range of other problems can occur. Policies and procedures for use of collections are designed to allow use in ways that minimize the risks to collections. Chapter 7 discusses how to make arrangements with a repository to use a collection physically, and chapter 8 presents access issues in the computer age. Here, we discuss what a repository does to enable access and use of collections including issues of accessibility and consultation, on-site use and loans, and publications.

To make collections accessible and useable, a repository must have good systems of inventory control and data management. These systems should allow repository staff to provide access to those materials that are needed by the user. Repository staff members have to try to anticipate the kinds of questions users will ask about the collections. They must then structure their data and information management systems in ways that are likely to provide answers to the most common kinds of questions or, at a minimum, to furnish leads to information sources that can be used to answer the questions. For example, it should be easy for a repository to answer the question "Do you have archaeological artifacts from Illinois?" On the other hand, answering the question "Do you have a Madison point from Feature 315 at the Goody Site that was excavated in 1902 by Hiram D. Igers?" could entail a records search for a number of similar objects unless the repository has a very sophisticated computer database or a very small collection. The inquirer may be invited to conduct the records search, depending on the number of objects and volume of records. In any case, a repository has to decide just how accessible information about its collections will be based on its individual circumstances, including the size and nature of its collections, funding, and staff.

Repositories also must decide the circumstances under which physical access to collections will be allowed. Not just anyone can walk into a repository and ask to use the collections; "curiosity seekers" almost never are granted physical access to collections. Because of the potential risks, repositories almost always limit physical access to collections to those persons who have needs linked to legitimate scholarly research or public education purposes such as exhibits. Even then, access usually is limited to those items pertinent to the user's needs. Users typically are not let loose in storage areas. Secure exhibitions, not storage areas, are the appropriate venue for the browser.

NAGPRA affects collections access and use at repositories that hold Native American human remains, funerary objects, sacred ob-

jects, and objects of cultural patrimony (McKeown et al. 1998). The process of inventory for NAGPRA compliance entails determining cultural affiliation through consultation with tribes. Consultation may involve tours through collections, careful consideration of appropriate handling of objects, and the need to accommodate traditional rites such as purification rituals.

Loans of collections to other institutions may be made for exhibitions or for research and teaching when in-house use is not feasible. Even small repositories often process a large volume of outgoing loans for exhibition and research. Some repositories do not have the facilities for scholars to use collections or do not have exhibits, so loaning collections is a way to provide access to both scholars and the general public. Procedures for loans made for both purposes are often identical and are intended to meet the needs of both the repository and the borrower.

Repositories have *loan policies* governing outgoing and incoming loans and the conditions under which they are made. *Loan agreements* are contracts that spell out the conditions of a specific loan, which must be signed by representatives of the borrowing and loaning institutions. Loan conditions may differ depending on the nature and intended use of the items. Borrowers almost always are responsible for the items they borrow, so repositories should make loans to institutions, not individuals. At large repositories, loan requests may be considered by a loan review committee and may need approval by the director or other administrator.

Other typical stipulations of loan policies include the following:

- Only properly accessioned and cataloged material are loaned unless there is a specific agreement that the borrower will do some of this work for the repository.
- Loans generally are made for the period of one year or less, subject to annual recall. The term *permanent loan*, although in common use, is a misnomer. *Permanent* implies that the borrower will always have the loaned item and thus may as well have title to it. The term *continuing loan* is preferable if an object will be loaned for an indefinite or lengthy period of time. Some repositories will not renew loans for more than five years.
- Unless alternate arrangements are agreed on in writing, all loaned items must be returned to the repository in the condition in which they leave.
- For research loans, collections returned must be accompanied by a report of findings, whether or not formal publication results. If for-

mally published, the repository receives a complimentary copy of the report.
- Borrowers may be subject to fees or costs involved in arranging the loan.

Procedures for setting up a loan usually include the following steps:

- Requests must be submitted in writing and addressed to the appropriate curator, collections manager, registrar, or director. Information on the intended use of collections, the requested duration of the loan period, and any other details pertinent to the request are necessary. Requests must stipulate the nature of collections use or type of research to be conducted, the accession and catalogue numbers of the objects requested, and a time framework. Research requests should also discuss expected results.
- A completed *facility report* must accompany exhibition loan requests. Facility reports describe the borrowing institution's security system, climate control, and so forth, as pertains to exhibitions. The American Association of Museums has standard forms that many institutions use.
- Each object or group of objects lent is documented on a loan agreement and may be photographed for record-keeping purposes.
- Specification of loan return is made at the time of the initial loan negotiation. Notification of loan return must be made in advance.

Repositories often receive requests for photographs of objects to be used in publications. Publicly owned repositories usually do not hold copyright to the images of the objects they curate, but private institutions may. Policies on use of photographs differ widely among repositories, but almost all institutions ask to receive a credit line on the published photograph, and users usually must pay the costs of photography. Many larger repositories prefer to have their own in-house photographer make photographs for publication purposes so they can ensure the quality of images of their objects and safety in handling.

Some repositories also publish their own series of research reports, catalogs, or other collections-related materials. As discussed in chapter 8, digital publications and catalogs, especially on the World Wide Web, provide new frontiers of public access to curated collections (see Toolkit, volume 7). In general, publications make collections more accessible because they provide detailed information in a format that

can be widely circulated. Publication policies and procedures differ considerably among institutions, depending on the kinds of series and available support.

CONCLUSION

Repositories have standard sets of policies and procedures for managing collections. Acquisition, accession, and cataloging procedures document the ownership status of objects and insure that an object stays linked to its documentation. Inventory control and data management procedures establish an institution's accountability for its holdings and facilitate finding objects in the repository. Conservation, collections preparation, and storage procedures help maintain the physical integrity of curated objects. The intent of all of these procedures is to enable controlled use of collections in order to maintain the safety and long-term preservation of the objects and associated records.

6

MAKING A COLLECTION: FIELDWORK PRACTICES AND CURATION CONSIDERATIONS

Overcrowded repositories and increasing demands for public accountability of stored archaeological collections force the field archaeologist to carefully consider what will go to a repository after a field project is completed. Future access to well-managed collections for research, interpretation, and exhibit can be assured only if thought is put into how to make collections *before* going to the field, while in the field, in the laboratory processing and analyzing the artifacts, and back in the office after the project is finished. The long-term management of archaeological collections, records, and reports is not just the job of a curator but a key responsibility of the field archaeologist.

The research design should help the field archaeologist make essential curatorial decisions even before going to the field (see Toolkit, volume 1). While in the field, the collecting strategy laid out in the project design should be followed, and the archaeologist must always be aware of changes that may have to be made due to unexpected circumstances. Basic principles of conservation must be followed to ensure that the collected objects are stabilized for further appropriate care and use. In the laboratory, decisions must be made about what parts of the collection will be saved for long-term care at its designated repository, including whether any highly redundant object types need to be sampled (i.e., discarded). These decisions have implications for how to process the various objects in the collection for long-term conservation and preservation. Finally, after the project is complete and the report and articles are written, the archaeologist must consider the ethical and professional responsibilities inherent in the long-term care and preservation of field notes, maps, photographs, draft reports, laboratory

notes, and the like. These documents hold valuable information for future scholars and should not get lost or destroyed.

BEFORE THE FIELD: PROJECT DESIGN

Two significant parts of a project design often are not given adequate attention: identification of a repository where the resulting collections will be curated and a well-articulated collecting strategy.

The Archaeological Resources Protection Act (ARPA) and its regulations (36 CFR Part 7.6[5]) require identification of a repository in advance of issuing a permit for any archaeological project on federal lands. Many states have similar requirements for compliance activities on state lands. However, university-based projects, often not conducted on federal or state lands, are rarely constrained by such requirements. Graduate students often learn by example to assume they can find room for the results of their fieldwork in a university museum, an anthropology department's storerooms, or their office after the project is over.

The archaeologist must select a repository before naming one in a project design. Chapter 7 provides more details on appropriate repositories for curating archaeological collections, but some basic guidelines are explained here. First, choosing a repository that is near the excavated site or surveyed land is a consideration, especially if the repositoty curates similar types of collections, thus enhancing the material's future research potential. The repository also must apply standard curation practices that permit well-managed collection growth (Sullivan 1992a; see also chapters 3, 4, and 8). It must have a mission statement, long-range goals for collections care and research, and a strong scope of collections statement. The scope of collections specifies the range of object types the repository will accept, along with other specifications such as regional or temporal foci. (Many state repositories only accept archaeological collections from their state or a few adjoining states.) The archaeologist should carefully examine this document and be aware that a repository can change its scope of collections statement and requirements. The repository may then be in a position to justify deaccessioning objects that do not fit the new scope and split up an archaeological collection.

Although no system exists to accredit repositories that meet the standards in 36 CFR Part 79, there are some other basic principles and questions to consider when choosing a repository. The archaeologist

must explore the methods the repository employs to accession, catalog (when not adequately done by the archaeologist), and inventory collections, as discussed in chapter 5. Does the repository use a computerized search and retrieval system to identify the items in each collection it curates and to easily find their storage location? The physical plant of the repository is also critical. Key questions that follow the standards set forth in 36 CFR Part 79 include these: Does it have appropriate temperature, humidity, and lighting controls for different types of materials? Does it meet local fire, building, electrical, health, and safety codes? Does it have an appropriate and functioning fire detection and suppression system? Does it have an emergency management plan with procedures to respond to flood, fire, and other natural disasters, as well as acts of violence or structural and mechanical failures within the repository itself?

The archaeologist also needs to consider whether adequate funding exists to fully document, preserve, and house a collection of objects and records. Does the repository charge a fee for curation? If so, is it based on a one-time-only or an annual fee structure? What services does the fee cover? Whether or not a repository charges a fee, does the project budget cover the expenses of preparing the collection for long-term curation in compliance with the repository's standards for acceptance (i.e., nondegradable and acid-free bags, tags, and boxes; archival-quality paper for field records; archival-quality preservers for slides and photo negatives, or basic conservation treatments)? The project design and funding proposals for an archaeological project should carefully budget for these needs. In some cases, particularly for work contracted by federal agencies such as the National Park Service, there are some established guidelines for budgeting curation (NPS 2000).

After a repository has been identified, the archaeologist must set up a curation agreement with the repository staff for accessioning and curating the final collection of objects. The agreement should clearly state the expected condition of the collection upon delivery to the repository and the responsibilities of the repository for the collection's long-term care and access. It should also clearly identify the owner of the collection. If any serious conservation needs are anticipated, these should be discussed in advance to determine whether and how the repository can provide appropriate conservation services. Because a repository may change its policies, it is critical that project archaeologists, repository staff, and any other significant parties (i.e., federal or state agency staff involved in project support) discuss how any policy changes might affect the project collection over time.

A well-developed project design also includes a sound collecting strategy. The collecting strategy must be based on the theoretical or compliance focus of the work, the phase of work (i.e., survey, testing, excavation), and, whenever possible, the long-term research plans for a region (Sullivan 1992a:4–5, 2001). Incorporating a collecting strategy into the project design forces thoughtful consideration of what artifacts and other archaeological materials (i.e., radiocarbon, soil, flotation samples) should be collected, retained for preliminary analysis, kept for long-term use, and added to a repository. Table 6.1 lists the critical components of a collecting strategy.

For testing and excavation projects, identification of the time periods of interest, as well as the primary classes of objects and noncultural materials expected to be recovered, is usually not difficult. They can be based on previous research conducted in the area and the phase of work planned. It is especially important to state these expectations for archaeological projects on federal land because the Archaeological Resources Protection Act (ARPA) allows for consideration of later claims that certain artifacts or noncultural materials were "inadvertently discovered." After due process, objects ruled to be inadvertently discovered can be discarded or deaccessioned. ARPA and its regulations, 36 CFR Part 79.5(d), also recognize only sites and objects over one hundred years old as archaeological and subject to curation. Without explicit statements regarding expected artifact types and their associated dates, portions of a collection made on federal land could be discarded or not accessioned if deemed to be "historical" and younger than one hundred years.

Table 6.1. Key Elements of a Collecting Strategy

1. The principal types of objects to be recovered (e.g., pottery, shell, metal, organics, construction materials) and their expected range of variation
2. The principal time periods of interest for the project A field and/or laboratory sampling regime for those objects that either do not fit within the project design or are highly redundant The principal types of noncultural materials to be collected (e.g., soil samples, radiocarbon samples, etc.)
3. A field sampling regime for each type of noncultural material to be collected (e.g., size and number of flotation samples per five cubic meters of soil excavated) in order to meet project goals
4. A justification and appropriate sampling strategy for excavating through deposits that are not relevant to the research design
5. A provision that allows for modification of the research design and collecting strategy, as well as renegotiation of the curation agreement, if significant amounts of unexpected material are recovered

As Black and Jolly emphasize in *Archaeological Research Design* (Toolkit, volume 1), even the best project design cannot always anticipate problems that will occur or unanticipated finds that will be recovered. The project design should always permit modification of the collecting strategy and the curation agreement when large numbers of unexpected artifacts are recovered or more noncultural samples must be taken than originally planned. Such modifications will recognize and record the research and interpretative value of the additional objects or samples.

IN THE FIELD: SAMPLING AND CONSERVATION

An archaeologist faces three key issues in the field that may have ramifications for the long-term condition of and access to the resulting collection: (1) sampling classes of objects that fall outside the project design or are highly redundant; (2) sampling noncultural materials; and (3) the impact of field methodology on the long-term preservation and conservation of the objects recovered, especially those whose condition and interpretive value may be jeopardized when removed from their archaeological context.

At least one class of cultural objects recovered during testing or excavation often is highly redundant, such as fire-cracked rock, shell, slag, or window glass. Occasionally, a class of objects may be both redundant and unrelated to the project design, such as body sherds from a time period that is not the focus of research. Despite the traditional practice of archaeologists to save everything for the sake of the discipline and in anticipation of new analytical techniques, these materials can take up considerable space in a repository and, after initial analysis, are never reexamined. Archaeologists must now be sensitive to the costs of curation and the possible need for repositories to deaccession highly redundant materials in order to provide access to the rest of a collection and room for new collections. Archaeologists, therefore, need to apply consistent procedures in the field and laboratory to sample classes of objects that may not fit the project goal or are highly redundant (Sonderman 1996). During fieldwork, it is critical to confirm the need to sample a particular class of objects as presented in the collecting strategy. Do this by monitoring the amount of material that is excavated and processed in the laboratory during the project. Then change the collecting strategy if necessary to reflect any unanticipated developments.

Soil samples and palynological soil columns have often been taken in large numbers without considering whether they will all be analyzed, what their long-term storage requirements are, and whether their impacts on storage space are manageable. The collecting strategy for such noncultural samples should obtain only the number of samples that will actually be used to achieve your project goals. You should process these samples quickly and efficiently so they do not become part of the permanent, accessioned collection of your project.

Field methods and on-the-spot decision making can influence the preservation and conservation of the excavated materials. A buried object is either in a state of equilibrium with its environment (soil, biological agents, and local climatic conditions) or in the process of adapting to it (Sease 1994). It begins to change when you expose it during excavation. Although changes to most objects are not visible to the naked eye, some objects become unstable and may begin to deteriorate in a matter of minutes or over several days. You must think and act like a conservator: what "first aid" interventions should be used as objects are uncovered in order to prevent partial loss or complete disintegration? Remember that an intervention is any sort of action applied to an object, whether deliberate or accidental.

Several basic principles of field conservation should be applied as objects are exposed, lifted from the ground, and packed for transport from the excavation unit (table 6.2.) Sease (1994:xi) reminds us that

Table 6.2. Key Conservation Principles for the Field (Cronyn 1990; Sease 1994

1. Always think about the excavation tools you are using. How might they affect the constituent materials and original shape of an object?
2. If you excavate a large object or a group of objects that are clearly unstable, quickly cover them up again and contact a conservator for advice on in situ treatment and appropriate removal methods.
3. Remember that water, temperature, humidity, and sunlight, among other factors, can affect the stability of an object as it sits in the ground while you excavate around it.
4. Lifting fragile objects out of the ground and carefully packing them for transport requires specific materials, such as consolidants, and considerable preparation. It must be done with great care. It is not recommended to glue a facing material (e.g., cheesecloth, tissue, toilet paper) directly to the surface of an object to facilitate lifting, because this is an intervention that usually causes problems in the long run.
5. Some objects can be seriously damaged when they are bagged at the site with other, inappropriate objects from the excavation unit. For example, do not mix bones with large, heavy lithics.

the "temporary" treatment an object receives in the field and laboratory is often its only treatment, so application of these principles may dictate the usability and survival of the collection.

IN THE LABORATORY: APPLYING THE SAMPLING STRATEGY AND MORE CONSERVATION

Whether under a tent near the excavation or in the repository prior to accessioning, the archaeologist must make several decisions and take actions to retain the short-term and long-term research potential of the collection. One step involves deciding what to save for the long term. Another is how to maximize object preservation by processing and conducting more "first aid" conservation on particular items.

Decisions about what objects to save may influence what conservation interventions are applied. Certain actions taken in the field to facilitate sampling and analysis can affect the long-term preservation and conservation of the kept objects, especially washing and drying. If soft potsherds are washed with hard bristled brushes, for example, their surface finish and decoration may disappear. If sherds or lithics are washed that have organic residues on or in them, information may be lost or altered permanently (see Toolkit, volume 5). If cleaning agents are added to the wash water, the introduced chemical contaminants may be damaging. Drying some objects in direct, hot sun may encourage partial or full disintegration.

Some culling of materials always occurs in the laboratory. Objects that are determined to be noncultural are usually tossed in the nearest garbage can. A carefully planned process of sampling and culling can be applied to highly redundant cultural materials or objects that do not fit the project design. From the beginning, this process must involve the assistance of an archaeologist specializing in the analysis of the material(s) to be sampled. It entails several steps, each of which must be fully completed and documented before the next one is taken.

The first step is to complete *all* the preliminary analyses of the entire collection in order to fully understand the range of objects it contains. This task involves counting and weighing classes of artifacts based on common attributes and writing general descriptions of them (see Toolkit, volume 5). The specialist in the targeted redundant artifact class(es) is especially important at this time. She or he should determine the range of variation and the artifact types present. For example, hundreds of kilograms of iron slag look pretty much the

same to archaeologists untrained in metallurgy. A specialist, however, might determine that a particular collection has several types of slag, each with particular and informative attributes.

After the types have been isolated, properly recorded, and described, the specialist must answer a very important question: *Now that the range of variation of this artifact class has been determined and the necessary analyses completed, should all of it be kept, or should samples be taken from the artifact types for accessioning in the designated repository?* To make this decision, the specialist must evaluate the following:

- The current state of knowledge of the artifacts and specimens
- The relative quantities of objects in each designated artifact type
- The range of variation within each type
- How the artifact types were distributed over a site or survey area
- The range of scientific methods that might be used to study the objects in the future
- The number and variety of objects needed for those studies

Once the decision is made to sample and cull, the second step is to define the appropriate sample size. Although the sample size should have been discussed in the project design and collecting strategy, it must be confirmed by the specialist in light of the known size of the project collection. Generally, the sample size needed for any future collections studies depends on the exact question(s) being investigated and the methods to be used. The goal should be to estimate the reasonable sample sizes that may be needed for future research, realizing that one can never completely ascertain what will be needed until a series of scholars try to use the collection. If the research methods are noninvasive, problems with the sample size should be minimal. If they are destructive, such as some chemical analyses, petrography, or metallography, the percentage of objects saved will decrease after each analysis.

The archaeologist does not have to take the same sample size for each artifact type. Some relatively rare object types might be sampled at 100 percent (all pieces are kept), while other object types with enormous numbers of objects can be randomly sampled at 10 or 20 percent. All decisions involved in this process and any significant observations made while removing the samples must be documented. This documentation must be kept with the final collection in the repository so future researchers understand exactly how the collection was created.

The next step involves handling the discarded materials. A place must be selected that, in the distant future, can never be mistaken as having a function different from artifact disposal. Appropriate places may be the middle of a fully excavated unit at your site or a municipal waste facility. Again, it is necessary to record where the culled objects were deposited in case someone wants to find them in the future or unknowingly stumbles upon them.

The final step is for the archaeologist to advise the curatorial staff at the designated repository about any employed sampling procedures. The same procedures then can be applied if the collection needs to be further sampled prior to accessioning in the repository. Such further sampling would only occur, however, under unusual circumstances and after prior consultation with the project director and object type or class specialist. Consultation with an official of the agency or bureau that owns the material also might be advisable if further sampling occurs at this stage of the process.

Whether sampling is done or not, other processing and conservation actions necessary to prepare the collection for long-term care and management must be considered (see Toolkit, volume 5). After cleaning and drying, these may include labeling, consolidation, reconstruction, and packing for transport to a repository. Table 6.3 lists important principles to follow when processing and providing first-aid conservation to objects. Try to ensure that it will be possible to reverse any intervention used over the long term without affecting either the object's constituent materials or future interventions that may become necessary at the repository.

IN YOUR OFFICE AFTER THE FIELD PROJECT: RECORDS MANAGEMENT

Archaeologists create a large amount of significant documentation before, during, and after a project: field and laboratory forms and notes, electronic data (e.g., databases, GPS, GIS), maps, photographs, video- and audiotapes, results of scientific analyses, administrative and legal paperwork, drawings of objects, preliminary and final reports, lecture notes, and published articles. One can never predict how these materials will be used in the future as archaeological methods and interests change over time, but one can be assured that they all have considerable value. Like the objects, they are the irreplaceable legacy of a project and its results (D. Fowler and Givens 1995). Every effort must be

> **Table 6.3. Key Principles of Object Processing and Conservation in the Laboratory (Cronyn 1990; Sease 1994)**
>
> 1. The best conservation approach is usually to do as little as possible. Minimize the use of interventive materials (e.g., glues, strengtheners, acids), and handle the object as little as possible.
> 2. Always think about the tools being used to clean, process, and conserve objects. Can they damage the object in any way?
> 3. Do not use any treatments (e.g., glues, consolidants) that may contaminate or scar an object for scientific analysis, such as chemical analysis or microscopy. If you are uncertain about the effects of an intervention yet believe that future analyses may be conducted, retain a sizable, unadulterated sample.
> 4. All conservation treatment must be reversible over long periods of time. Glues or consolidants, for example, must be removable without any negative effect to the object and its constituent materials. Remember that acids to remove concretions permanently alter an object.
> 5. To ensure reversibility, only use interventions that have been well tested over time and whose aging properties are well known. Note: Tests on Elmer's glue show that it becomes insoluble in water over time and cannot be reversed.
> 6. All interventions must be fully and accurately documented, especially the materials used. Years from now, a conservator may need to do additional interventions or a researcher may select your objects for scientific analysis. They must know the conservation history of the objects.
> 7. Make sure the treatment records become part of the permanent record of the project.
> 8. Conservation interventions often involve chemicals that must be properly and carefully transported, stored, and disposed of.

made to prevent their discard or separation into disassociated parts as archaeologists move between jobs or into retirement, or their complete loss after a death. Documentation associated with federally sponsored projects is considered an integral part of the overall project collection, as well as the property of the government.

It is understandable that some archaeologists may not want to give up some of these records during their archaeological careers. They may need access to them for lecturing, writing, or further research. Also, one can never be sure how records might be used by others in isolation from the original work and aspirations. Archaeologists can take three critical steps to maximize the long-term care and management of, as well as access to, the records and reports they make.

The first task is to designate a repository or archive to curate the materials. This step needs to be done in a legal document, such as a will or a formal agreement with the repository. An archaeologist

should spend some time determining the best place to deposit her or his records (Parezo and Person 1995). There should be a logical association between the individual and the repository or archive. It can be the university where the archaeologist taught for many years, the repository that holds most of the artifact collections she or he generated, or a repository with an excellent reputation in the state or region of the work or in the disciplinary specialty. Once several potential repositories or archives are identified, the records collection should be discussed with the staffs. Does the repository have a full-time archivist? What is the scope of collections of the repository? How does it handle the particular storage needs of paper records, film negatives, printed photographs, audio- and videotapes, and electronic media? How will your materials be made accessible to the scholarly and general public? Does the repository have any requirements of its potential donors, including monetary conditions?

The second step is always to be aware of the need to preserve documents and records as they are created and while they are in the archaeologist's possession (Kenworthy et al. 1985). There may be paper records, 35mm film, videos, audiotapes, maps, and computer files, so concern about the different, long-term storage requirements of each format is necessary (Griset and Kodack 1999). The most important principle to follow is to use quality materials. Even a "poor" graduate student doing dissertation research should budget for the necessary archival-quality materials to preserve the records over the next forty to fifty years of her or his career and well beyond.

The third step is to retain an electronic copy of all reports, including limited distribution CRM reports. The discipline values the contents of gray literature reports (Lipe and Redmond 1996), but it is often difficult to obtain copies once the limited number of printed copies is distributed. Some reports are available on the Internet, and in the future it may be possible to make full electronic copies of most reports broadly accessible. The archaeologists should make sure that appropriate, centralized facilities (e.g., State Historic Preservation Offices) and regional libraries receive a paper copy at least. Also, report citations need to be entered into appropriate state, regional, and national bibliographic databases (e.g., the National Archeological Database, Reports module), which help researchers find the results of previous work. Table 6.4 provides some other key principles to follow concerning the care and long-term preservation of records and reports.

Table 6.4. Key Principles for the Preservation of Project Records (Griset and Kodack 1999; Vogt-O'Connor 1996, 1997, 1999; Vogt-O'Connor and van der Reyden 1996)
1. Make at least one copy of all written records, including field notes and forms, laboratory notebooks, and administrative documents, on archival paper.
2. Send a copy of your field notes, including descriptions of field conservation and artifact sampling procedures, to the repository that is curating your artifact collection.
3. Make a copy of all computer-generated documents and data files on archival paper.
4. Make a backup copy of all computer generated documents and data files. Label them fully with information about the associated project, date created, and software used. Keep a copy of the software application used to generate the data or documents because it may quickly become obsolete.
5. Recopy all computer files and applications onto fresh media every five to ten years.
6. Process all film at laboratories that test for destabilizing chemicals.
7. Use appropriate containers for proper archiving and long-term preservation of 35mm film negatives, printed photographs, slides, 8mm movie film, and videotapes.
8. Label all photographs, maps, video- and audiotapes, and drawings minimally with the name of the creator, date created, and description of the item.
9. Store records in acid-free folders and boxes.
10. Enter bibliographic citations of your unpublished and published reports in regional and national databases, and, whenever possible, submit electronic copies of your full reports to databases that can store large documents. |

CONCLUSION

Decisions made prior to, during, and after fieldwork have significant ramifications for the long-term care and viability of the archaeological collections. Therefore, archaeologists are directly responsible for the collections they make. The importance of considering collections care and management early in the project design, and the need for a collecting strategy, cannot be underestimated. Conservation and sampling issues that arise during fieldwork and soon thereafter in the lab also need consideration. Finally, it is very important for archaeologists to preserve and provide for the care of the documents and records they generate over their careers.

7

 WORKING WITH A REPOSITORY

The intent of this chapter is to acquaint archaeologists with typical policies and procedures related to making curation arrangements with repositories and using archaeological collections that are curated by a repository. Of course, no two repositories are alike. Specific policies and procedures will differ between institutions, but the general framework discussed here will provide an idea of what you can expect.

ARRANGING FOR LONG-TERM CURATION

One of the major points of this book is that curation begins *before* a collection is made. Identifying a repository and becoming acquainted with its policies and procedures is an initial step in planning a field project (see chapter 6). An archaeological collection should not be made until and unless there is a repository that can and will care for it. The search for a repository typically begins within the general geographic region (e.g., the state) from which the collection originates. State museums usually can offer assistance and may themselves be appropriate repositories. Federally owned and administered collections may have designated repositories with curation agreements in place. This arrangement alleviates the need for the archaeologist who is making a collection to find a repository, but not the need to follow pertinent policies and procedures.

CURATION FEES

Many repositories charge curation fees, particularly for collections resulting from CRM projects. Fees typically are tied to the size of a collection (e.g., number of boxes of a certain size or total cubic feet). Artifacts, other specimens, and records are often included in size calculations. Fees vary widely but tend to be similar within regions (Childs 1998; see chapter 8). The kinds of services repositories offer on a fee basis also vary. Some institutions will do cataloging, while others will not. Charging fees to funded projects is simply one way repositories are dealing with the curation crisis. Curation fees rarely, however, reflect the true total costs of curating a collection "in perpetuity." Many institutions charge fees that reflect only the costs of actually getting a collection installed in their facility—for example, storage furniture, additional staff time for placing collections in storage, and inputting data to a computerized inventory.

WHICH REPOSITORY IS APPROPRIATE?

We briefly discussed some of these issues in chapter 6, and in chapter 4 we described kinds of repositories and their governing structures. A repository that is appropriate for long-term curation of archaeological collections may be organized in any one of the ways discussed in chapter 4, but not all repositories are appropriate for the care of archaeological collections or for specific kinds of archaeological collections. Making informed judgments regarding a proper curatorial institution often is a responsibility of the archaeologist making a collection. Some institutions would quite willingly take an archaeological collection but are inappropriate repositories.

A primary concern is whether a repository is a legitimate long-term institution. Is the institution configured to exist and continue curating collections after the individuals currently responsible are no longer involved? Evidence of such long-term interest may take the form of a charter or incorporation, depending on the laws of a particular state. To curate archaeological collections "in perpetuity," the repository itself must be configured legally to exist in perpetuity or minimally to have a legal agreement as to what will become of the collections if the repository closes. Collections in the public trust usually should not pass into private ownership. If a potential repository is privately rather than publicly owned and the collection in question is (or will be) in the public trust, it will

be especially important to make legal provisions for protecting the collection.

A second question to ask a repository is whether it curates research collections. As explained in chapter 5, an institution's mission statement and scope of collections or acquisition policies define the kinds of collections a repository acquires and the uses it makes of them. Institutions that curate collections mainly for exhibition or for teaching are not likely to be appropriate curatorial facilities for archaeological materials of research value. Related to this concern is whether the institution already is curating professionally generated archaeological collections with significant research value. Many local historical museums curate prehistoric or historic objects that originated in archaeological deposits, but these collections typically are antiquarian in nature, not archaeological, as we defined in chapter 1. Such institutions may be very interested in having an archaeological collection to add to their displays and may even offer to take it for "free"—that is, to charge no curation fees, especially if the collection originated in their geographic area. Such institutions may not have staffs that understand the importance of records and provenience to an archaeological collection and, although well intentioned, may inadvertently destroy the research value of the collection. This problem certainly does not pertain to all local historical societies or small museums. Many smaller institutions have very capable staffs and well-curated collections. The archaeologist who is making curation arrangements must make sure the repository is indeed an appropriate one for archaeological collections (see chapter 6). It is always prudent to seek advice from the staff of a reputable repository that curates archaeological collections in a nearby region.

Once it is ascertained that a specific repository is a legitimate institution that curates archaeological research collections from the collection's geographic area and that public-private ownership issues are not a problem, the next step, if possible, is to make an appointment to visit the repository. A visit is important if the archaeologist expects to be doing fieldwork or other research in the region. Establishing a working relationship with a good repository is essential to the successful completion of a field project. Repository staff can provide advice and assistance regarding curation issues throughout a project. If a repository has agreed to curate a collection, the staff typically is happy to provide such aid because in the long run, their work will be made easier if everything is in order and problems are resolved before they receive the collection.

ACQUISITION POLICIES AND PROCEDURES: WHAT TO EXPECT

Making arrangements for long-term curation of an archaeological collection need not be a frustrating or overly time-consuming process. Problems may arise, though, if the archaeologist who is making a collection does not choose an appropriate repository or is unaware of the expectations a repository is likely to have. In the past, some archaeologists assumed that all they needed to do to get a collection curated was to show up at a repository with the collection and expect that they would be greeted with open arms and profuse thanks. Such expectations typically led to disappointments and poor working relationships.

As noted in chapter 5, reputable repositories have acquisition policies and procedures that must be followed in order for materials to be accepted into their collections. Reputable repositories also have policies and procedures for using the collections they curate. These policies are not meant to thwart the researcher; rather, they are mechanisms by which repositories methodically build and care for collections. If collections policies and procedures are understood and followed, and if the repository is an appropriate one for the collection in question, curatorial transactions usually go smoothly.

ACQUISITION DECISIONS

Repository staff members consider several factors before reaching a decision on whether to acquire a collection. These include how well the collection fits the institution's scope of collections policy, the collection's ownership status, and whether the repository can adequately care for the specific collection in question (i.e., space and conservation considerations). Depending on the institution's size and organizational structure, an individual or a committee may make acquisition decisions. Decisions made by staff also may take the form of a recommendation that must be approved by a board of directors before an acquisition can proceed.

Some paperwork is necessary to initiate a curation agreement. The amount of paperwork typically varies according to the size of the institution. Larger institutions have larger and more specialized staffs and usually need more paperwork because more people are involved in acquisition decisions and collections care. In smaller institutions, only one person may be responsible for all aspects of curation. If so,

the curation agreement may simply involve an exchange between the field archaeologist and the individual curator or collections manager. In any case, the agreement should always be specified in writing. A letter may suffice.

The archaeologist should be prepared to provide a written description of the collection. Because this description may be required before the collection actually is made (before fieldwork begins), the description minimally will need to include this information:

- The site or locality of origin
- Ownership status
- The collecting and recording methodologies to be used (e.g., survey, testing, full-scale excavation, number and size of excavation units, screen size, photographic records)
- The anticipated kinds and volume of materials (e.g., flotation samples, digital photos, metal objects)

Providing the repository staff with a copy of the research proposal often is the simplest way to furnish much of this information.

Depending on the institution's size and the complexity of the collection in question, acquisition decisions may take several weeks. This is yet another reason why establishing a relationship with a repository is beneficial for both the field archaeologist and the repository. Acquisition decisions often can be made more quickly if the repository knows what to expect. It may be possible to arrange curation agreements that cover more than one field project or more than one field season of the same project, which should benefit both parties by reducing paperwork.

The most common reasons a repository may turn down a collection are problems with ownership and physical considerations of the collection. Collections with unclear ownership are a bad investment for repositories. Curation fees never pay the entire cost of curation in perpetuity, and repositories understandably are reluctant to invest precious curation dollars in materials that could be claimed by other parties. As discussed in chapter 3, a collection originating from private land almost always belongs to the landowner. If the landowner has agreed to donate the collection, the archaeologist making the collection should be prepared to have the landowner sign a deed of gift that transfers ownership of the collection to the repository. A verbal agreement to donate the material to the repository is not sufficient to transfer ownership because in subsequent years, the donor's heirs

may be able to claim the collection. One of the many advantages of having a curation agreement in place before beginning fieldwork is that landowners are more likely to donate materials to a specified museum than to give the materials to the field archaeologist. This situation arises because the notion of having the materials displayed or available for research often is attractive to a property owner, and it is particularly true if the landowner is unhappy about how a CRM project has affected his or her land.

Space and conservation are the main physical considerations that influence acquisition decisions. Storage space is a ubiquitous problem in repositories. It simply may not be possible for an institution to accommodate a large collection or one that includes large objects, even if the collection otherwise is an appropriate acquisition. Collections with items that need extensive conservation treatment, such as waterlogged objects, also are difficult for most repositories to accept. Few repositories have in-house conservators, and those that do typically have not had them for long. The backlog of objects needing treatment may be great, and adding to such a backlog may not be prudent. Contracted conservation treatment is expensive, and most repositories do not have much funding for conservation. Given these problems, a repository may require the archaeologist who makes the collection to include funds for conservation treatment in her or his budget.

COLLECTIONS PREPARATION AND DELIVERY

Preparing the collection for long-term curation usually is the responsibility of the archaeologist making the collection. Much of this effort is laboratory work that the archaeologist must do before analyzing the materials. Any reputable repository will have guidelines for collections preparation including how the materials are to be cleaned, labeled, cataloged, and arranged and the kinds of containers in which they are to be placed. Records—either the originals or very good copies—also must be organized and prepared for the repository. As noted in chapter 6, records that must accompany a collection include those that explain the setup and research design of a project (e.g., proposals), as well as field, laboratory, and analytical records, maps, and reports. A repository may require copies to be on acid-free, archival paper and that photographs be archivally processed. Instructions for preparation procedures and other information about vendors for specific kinds of storage supplies should be obtained from the

repository staff. Should any of a repository's preparation guidelines be at odds with certain specialized analytical procedures, the archaeologist should make the repository staff aware of this problem so that accommodations can be made.

Delivering the collection to the repository also is usually the responsibility of the archaeologist making the collection. Repository staff should be contacted to schedule a mutually agreeable time. Many repositories have check-in procedures to ensure that everything is in order when a collection arrives.

SUMMARY

An archaeologist setting up a curation agreement minimally should expect to:

- provide the repository with some fairly detailed information about the collection;
- await an acquisition decision;
- pay curation fees, especially if it is a CRM project (see chapter 8);
- possibly pay for conservation treatment;
- prepare the collections according to the repository's guidelines;
- include records with the artifacts and specimens;
- deliver the collection to the repository at a mutually arranged time; and
- receive written confirmation from the repository that the curation agreement is in effect.

USING CURATED COLLECTIONS

One of the main reasons to curate archaeological collections is to make them accessible for continuing research, but this is not the only purpose for which archaeological collections are used. Repositories, especially public museums, receive requests for access to collections they curate from a myriad of individuals and other institutions. Policies and procedures for collections use are designed to identify those users who have legitimate purposes and to ensure the safety of the collections.

Unfortunately, some archaeologists believe they can show up whenever they wish to use a collection and any request for use will

be granted immediately. Such expectations will only lead to a poor working relationship with the repository. Archaeologists wishing to use curated collections must be prepared to supply the repository staff with information about their intended purposes, to provide information about their facilities if they intend to borrow materials, to be somewhat flexible about the specific materials that may be borrowed, to justify requests for destructive analysis, and possibly to have their requests denied.

Another consideration of using curated collections, especially older ones, is that the researcher cannot expect to find all of the information or documentation that would result from more recent excavations. The context and time period of the fieldwork greatly influence the content of collections, including the types of specimens and data collected. For example, systematically collected botanical remains do not exist in WPA-era collections such as those from the Chickamauga Basin (see chapter 2) because archaeologists did not use flotation techniques then. Users of older collections thus must be prepared to be creative about their data needs and to structure research questions that are compatible with available data. But before collections can be used, they must be found.

FINDING COLLECTIONS

A major challenge in using curated archaeological collections often simply is identifying where the collection is curated. This problem slowly is being overcome as more repositories make their catalogs accessible though the Internet (see chapter 8). Nevertheless, it will be several decades before information about most curated archaeological collections is readily accessible electronically. Until then, word of mouth and dogged research still are standard ways to locate specific collections. Even when collections information is available online, data needed for particular research problems rarely will be available from computer databases that are designed to manage collections. Such databases generally inform users about the kinds of materials in an institution's holdings, but they rarely provide analytical data.

Collections from one archaeological site or project may be curated at different repositories. This circumstance is often unavoidable if a site or project is large and had many investigators. Knowing who has worked on a project can help a researcher find parts of some collections. Sometimes material classes sent to specialists for analysis are

not returned to the repository that curates the rest of the collection. Instead, the materials become incorporated into the collections of the specialist's institution. The institution probably has no title to these materials, may not even be aware that the materials belong to another institution, and sometimes will not return the materials to the original repository if that institution requests them. Loan agreements with specialists can help avoid such problems.

Specimens also become separated from the rest of their original collections through the use of "type collections." For example, when the ceramic repository at the University of Michigan was started (see chapter 2), samples of sherds from sites all over the eastern United States were sent to Michigan. Researchers studying major older collections may well find some "missing" sherds in Ann Arbor.

Quite often, associated records are separated from collections and in too many cases are lost. Every archaeologist knows that an unprovenienced artifact is worthless for research purposes; similarly, repositories and archaeologists should view records as integral parts of archaeological collections. Often records were considered the personal property of archaeologists, or they were never sent to the institution that had the specimens. Tracing the employment history of the archaeologist and making inquiries of those institutions may find these "lost" records. The Council for the Preservation of Anthropological Records (CoPAR) is encouraging anthropologists and archaeologists to arrange for their papers and records to be placed in proper archives, either at retirement or through their will (D. Fowler et al. 1996). Another step forward is the insistence by repositories that records *must* accompany the specimens in order for them to accept an archaeological collection for curation.

Once a collection is found, the next step is to arrange to use it. This requires a previsit contact with the repository.

ARRANGING USE

Repositories usually want the collections they curate to be used, but repositories also must ensure that the use of collections is appropriate and does not endanger them. The repository also must ensure that collections will be accessible to many generations of users, not all of whom will be archaeologists. Archaeological collections may be used in three general ways: at the repository (on-site), at other institutions (loans), and for destructive analysis.

ON-SITE

Repositories prefer collections to be used in-house if practical. Some items may be available only for on-site use, such as original records and fragile artifacts. Arranging on-site use is simple. Usually a phone call or a short letter identifying the collections to be used and the general purpose (e.g., measurements, photography, etc.) is sufficient to set up an appointment with repository staff. Some institutions limit the purposes for which photographs made by nonstaff can be used, so it is important to discuss this issue if photography is an intended use. Also, the repository must approve any use that would alter an item. Discussions and approvals usually can be taken care of before a visit so that time during the visit can be used efficiently. Many institutions also have procedures intended to preserve and protect the objects when handling collections items (e.g., wearing gloves). The user should respect and follow these procedures.

LOANS

As explained in chapter 5, reputable repositories make loans of collections and individual objects to institutions, not to individuals. Depending on the size and organization of the repository, a registrar, collections manager, or curator may make loan arrangements. The individual requesting a loan usually must be an employee of the borrowing institution, although a loan can be made so that a nonemployee can use a collection at the borrowing institution. For example, a faculty member may arrange a loan from a museum to a university so that a graduate student can use the materials in the faculty member's laboratory.

Loans can be made for research, exhibition, or teaching. In general, repositories will make loans for research purposes at the request of, and for the use of, legitimate scholars at institutions that have reasonably secure laboratory facilities. Very fragile or monetarily valuable objects usually are not loaned for research purposes, nor, as mentioned earlier, are original records. Loans for exhibition can be made only to those institutions with secure exhibit facilities. For example, an institution that has guards, climate control, and locked cases would be loaned objects for exhibition, but not an institution without such facilities. Loans made for teaching purposes—materials that will be used in the classroom and handled by students—generally will be items that have

little research or monetary value and are not fragile. Exceptions include loans for laboratory methods classes in which students do collections preparation work such as cataloging.

Loans are made for specified lengths of time and typically can be renewed. As explained in chapter 5, there are no permanent loans, but continuing loans can be arranged in certain circumstances. The borrower usually is expected to pay for transportation of the loaned materials. The kind of transportation depends on the kinds of materials, the distance to be traveled, and the risk and costs. Shipping companies that specialize in moving museum objects can be expensive, but transportation in a personal vehicle involves liability. The borrowing institution is responsible for damage or loss of the loaned materials.

DESTRUCTIVE ANALYSIS

Requests for destructive analysis, such as for radiocarbon assays, neutron activation analysis, or chemical tests, typically require detailed justifications and longer turnaround times for review. The reason is that destructive analysis either removes an object permanently from a collection or permanently alters the object thus changing its integrity. A repository may regard destructive analysis as akin to a deaccession. If this is the case, approval of the repository's board of directors may be required.

NAGPRA neither specifically authorizes nor prohibits destructive analysis of human remains or other items in collections that fall under its purview (25 USC 3003; 93 CFR 10.9 and 10.10). However, it does require consultation with affiliated tribes, and it instructs museums to retain unaffiliated humans remains until final regulations are promulgated or unless legally required (or recommended by the secretary of the interior) to do otherwise. Therefore, destructive analysis of any material that may relate to NAGPRA should involve tribal or legal consultation.

Sample size must be considered if the proposed analysis will remove most or all of a material category from an archaeological provenience. For example, it may not be prudent to allow destruction of all examples of one kind of seed from a site, nor may it be wise to permit destruction of all of one kind of sherd or tool from a specific provenience. Removal of these items may diminish the potential of the collection for other types of research. Where sample sizes are small, the researcher requesting permission for destructive analysis

should identify several alternate samples so the repository staff can consider which alternate would have the least impact on the collection's long-term research potential.

CONCLUSION

Repositories balance the benefits of proposed uses of collections with long-term preservation needs. Different uses pose different risks to collections, risks that may affect other uses. Repositories want to ensure that by granting use for one purpose, they are not allowing the *last* use that can be made of irreplaceable materials. Archaeologists requesting use of collections should think about the impacts of their request on the long-term accessibility and availability of the materials. Requestors and repository staffs then can work together to make mutually beneficial arrangements. Uses that enhance the interpretation, cultural significance, research potential, and accessibility of collections all are in the best interests of repository staffs and archaeologists.

8

THE FUTURE OF ARCHAEOLOGICAL COLLECTIONS CURATION

In this final chapter, we focus on the future of archaeological curation in terms of three primary issues:

- Access to and accountability for collections in the computer
- Use of collections for research and public benefit
- Support for the high costs of curation over the long term

Our interest in these topics relates to several simple questions that the public and Congress might ask any archaeologist or curator:

- If we do not know what is in a collection and therefore cannot use it effectively or efficiently, why keep it at all?
- What funding mechanisms exist to cover the significant costs involved in ensuring that collections are useable, accessible, and in optimal condition?
- Is it all worth it?

ACCESS: COLLECTIONS IN THE COMPUTER AGE

We have said it before and will say it again: An archaeological collection and its documentation are the only tangible legacy of an archaeological project, whether survey or major excavation. Collections should be highly valued, preserved, and made accessible for use by researchers, educators, interpreters, and the public, especially those whose heritage is tied to the materials.

These seemingly simple goals have some important caveats. First, as noted in chapter 7, ethical and practical issues are related to balancing access and appropriate use with protecting and preserving the collections and documentation for the long term. The balance is particularly sensitive when a collection contains items that are rare or fragile, require special conservation, or have other characteristics favoring restricted access. Second, some repositories do not have adequate space for study and use or enough staff to monitor users against theft and unacceptable handling of collections. Third, some laws and repository policies control access to collections and documentation related to specific descendent groups, such as the sacred objects and human remains of Native Americans.

Effective user access to a collection and its documentation requires, at a minimum, an inventory of its contents and information on its storage location(s). Users also must know of any restrictions on access to a particular collection. It is no simple matter for a repository to assemble and organize this information for one large collection or its many different collections. Fortunately, computer technology and information management expertise can assist.

Archaeologists have used computers for decades to help manipulate and better understand data accumulated during a project (Scholtz and Chenhall 1976). Curators and managers of archaeological collections also have understood the benefits of using electronic media to catalog and inventory collections for search and retrieval purposes (Marquardt 1977b; Peebles and Galloway 1981). Budget limitations and uneven staff expertise meant that repositories entered the computer age at different times, developed their technology at different paces, had different expectations for their technology investments, and encountered different problems. To complicate matters, repository staff could not have known that the Internet would permit remote access to collections.

DATABASES

Computers allow collection managers to inventory and describe huge numbers of items and related records, to quickly retrieve basic descriptive and storage information, and to find items in storage (Chenhall and Vance 1988). These information management capabilities improve collections accountability and allow for better budgeting of future collections, including more efficient inspections, routine conservation work, and basic equipment needs.

Despite progress in the adoption and use of computerized cataloging and inventory systems at least five problems and limitations need attention: (1) changing registration systems, (2) cataloging backlogs, (3) maintenance of electronic data and the application used to access it, (4) sharing data, and (5) knowledge of and access to gray literature.

First, many older repositories retain several registration systems that evolved over decades. It can be difficult to integrate the systems into an efficient information storage and retrieval system without losing critical information, such as handwritten marginal notes on an object (Bell 1990). Nonetheless, years of effort to integrate and produce an electronic registration system for the anthropology collections of the National Museum of Natural History have proven beneficial (Krakker et al. 1999).

Second, many repositories have enormous cataloging backlogs and face significant annual increases of new archaeological collections. Automation of the process has helped considerably, but the costs are also enormous (GAO 1987; Hitchcock 1994). Trained staff must be devoted to backlog cataloging when many other tasks also have high priority.

Third, automation requires long-term maintenance of both the software applications and the data gathered. Maintaining a database of any type requires upgrading the application software as new technology develops and/or migrating all existing data to a new application as a repository develops new data management needs. The data, including digitized images, must be backed up and stored in a secure location, and periodically copied to new storage media to prevent loss (Vogt-O'Connor 1996, 1999). Use of computer technology definitely is not cost-free. Hardware and software for collections management, like the collections themselves, require baseline funding and staff expertise for long-term upkeep.

Fourth, sharing and transferring basic data about collections among repositories or between repositories and potential collection users is difficult at this time. No set of standardized data fields exists for use by all repositories with archaeological collections (Marquardt 1977b; Woosley 1992), although some agencies such as the National Park Service have one set of internal standards for all its more than three hundred park repositories. Because there is no overall set of standards, some critical data often are not collected, such as the ownership of the collections that a repository manages. It is difficult, as a result, for federal bureaus and agencies to account for

and gather basic information on their collections housed in many different repositories (Ferguson and Giesen 1999). This problem would be resolved if all repositories carried an ownership field in their databases, as the Natural Science Collections Alliance success-fully promoted for natural history collections. Likewise, few reposi-tories link their accessions records to geospatial references for use in Geographic Information Systems (GIS). Doing this would aid in a wide array of research and management efforts.

Fifth, the number of archaeological reports has dramatically in-creased over the last twenty years. Few of the gray literature reports are available in libraries or bookstores, so they need to be systemati-cally recorded, abstracted, and indexed. Accessibility to basic infor-mation about such reports promotes wider recognition and use of their contents and less duplication of effort (Ford 1977; Marquardt 1977b). The National Archaeological Database (NADB) Reports mod-ule is such a bibliographic database of gray literature that has been implemented at the national level (Canouts 1992). Its principal draw-backs are that it is difficult to keep up-to-date and that it lacks a stan-dardized thesaurus of keywords for use in searching the database. Access to full reports could be achieved by digitizing each printed page of old reports and distributing via CD-ROM or the Internet. Bringing the huge numbers of gray literature reports onto desktops in this way will require considerable funding as well as careful attention to backing up the files and periodic copying to new storage media.

INTERNET

The Internet can significantly aid and transform access to and use of archaeological collections, records, and reports. The World Wide Web is a particularly useful tool for public outreach and education about archaeological collections (see Toolkit, volume 7). The Web may be accessible from a user's home, local library, office, or school. This ac-cessibility means that a user can learn about a repository and its col-lections without traveling to it. For archaeologists, it can provide a critical introduction to particular collections, but it will never be a complete substitute for an on-site visit to a collection.

The Web has multimedia capabilities so that information about collections can be provided in a wide variety of formats, including text, two- and three-dimensional color photographs and images, video, and audio. Researchers can view objects from afar and make in-

formed decisions about whether to travel to the repository for more in-depth study. For the repository, a significant advantage of remote access to specific objects is that the objects and documents, especially fragile items, are handled less and repository staff are not needed to supervise users.

With careful organization of a website, a repository can target several different audiences, such as researchers, interpreters, and the public, at the same time. Clever organization and design may offer several doorways for entry into a repository's website, one for each type of audience, including kids. A website also can be changed, updated, or enhanced with much greater ease than a book or film. New services may be added to a site when useful or removed if unsuccessful.

Table 8.1 summarizes services a repository might offer through the Web to promote access to its collections. The appendix provides a list and brief description of some websites that offer such services.

Like in-house databases, the Web can provide more information about archaeological collections than has ever been possible. However, a website is not necessarily cheap or easy to create. Large and complex sites that offer information and services to different audiences require considerable investment in hardware and software, creative thought and skills related to content organization and Web design, and funds to pull it all off. If a website is easy to navigate and users routinely find interesting materials, people were involved behind the scenes to anticipate the needs and demands of their designated audiences. Furthermore, like databases, a website must be maintained. A repository cannot expect to launch a website and sit back. The content must be reviewed periodically and the links must

Table 8.1. Possible Web-Based Services for Access to Collections and Documents

- Multiple media: text, 2D and 3D photographs and images, video, and audio
- Searchable databases, such as collections and archive inventories
- Online exhibits of one or more collections
- Object type collections for research
- Repository policies, as well as forms for access and use
- E-mail for direct communication
- Links to contextual information about the archaeological project from which a collection came, even when not provided by the repository

be checked. Finally, a repository cannot rely on a website as its only vehicle of communication because the Internet is not available to everyone. A repository should use a website as one of several strategies to inform its audiences about its collections.

USE OF CURATED COLLECTIONS

A recent study of leading U.S. anthropology departments examined the primary sources of data used for Ph.D. dissertations (Nelson and Shears 1996). The findings revealed that, in 1990, 16 percent of doctoral research used museum collections, while in 1994 and 1995, 30 percent primarily used collections. This jump suggests that fewer site excavations are being done by U.S. academics, possibly due to diminishing research funds and an increasing conservation ethos, perhaps stimulated by NAGPRA. It also suggests greater appreciation among graduate students for the research value of collections.

This trend sets up many difficult challenges. The first is getting archaeological curation introduced into graduate curriculum. Even now, with ongoing major discussions among archaeologists about curriculum reform (Bender and Smith 2000), curation is omitted as a topic to be included in graduate curriculum. Curation cannot continue to be a "back burner" issue or the responsibility or problem of others. As federal and state agencies, their partner repositories, and many other repositories work to provide good access for the use of properly managed collections, graduate faculty must understand and teach the complexities of archaeological curation, including the value and proper use of collections for research and public benefit. This necessity now is part of the ethical guidelines of the SAA (Childs 2002). Additionally, increased use requires increased collaboration between repository personnel, CRM practitioners, archaeologists in academia, and cultural groups whose heritage is represented.

THE "BIG PICTURE": CURATED COLLECTIONS AS SAMPLES OF THE ARCHAEOLOGICAL RECORD

Lipe (1974) first suggested preservation of a representative sample of regional archaeological resources as a response to the increasing loss of intact sites. Later, Dunnell (1984) and Salwen (1981) suggested that because archaeological resources are nonrenewable, preservation of a

representative sample is the most ethically defensible strategy for the general management of archaeological resources. "The representation problem is . . . one of insuring that the patterns of kind, quantity, and distribution are preserved in those archaeological materials that persist beyond impact" (Dunnell 1984:71).

This approach can and should be extended to curated collections. Not only must we seek to manage collections growth, but the actual growth of collections must include samples that represent specific kinds of archaeological resources. Collections by their very nature are samples, and what is curated directly affects the character of the preserved archaeological record. Explanation of variability in the archaeological record is a main focus of archaeological research. Preservation of a representative sample of archaeological resources in curated collections can ensure persistence of this variability and allow future archaeologists to study variability and its causes. If such research is to continue, however, collections from one type of site or resource must not be curated to the exclusion of other kinds. Various kinds of sites, features, and materials must be represented in sufficient, yet practical, quantities to allow meaningful comparisons.

Defining the composition of a representative sample is fraught with difficulties but is not impossible. Artifact types must be categorized to structure the sample. Sampling plans need to consider various categorical levels and scales of analysis, such as kinds of sites, contexts (e.g., features), artifacts, and noncultural samples. Representative samples of site types have been defined successfully in some regions, yet the criteria employed to define categories for future research must transcend, to the extent possible, the restrictions of current archaeological concerns and biases (Glassow 1977:414). Dunnell (1984:71–72) notes the problem of assuring representation when blind sampling is necessary and suggests that a spatial frame of reference can provide an independent control. For example, consider that a settlement system for a certain time period in a region is not well understood. A sampling scheme that seeks to collect samples and information from sites of this time period in the represented environmental contexts would be one way to approximate a representative sample of the related archaeological resources (see Toolkit, volumes 1 and 2).

A complementary problem is determining the proportional quantities of the sampling categories. This issue can present difficulties when samples must be drawn from numerous, broadly distributed archaeological resources, as well as rare or localized occurrences (Dunnell 1984:72). For example, in the hierarchical settlement systems of

complex societies, large sites with rich deposits form a small proportion of the sites in a region. Yet, given the diversity of materials and data potential of these sites, a strong argument could be made for curating collections from a larger proportion of such sites than from other types of sites. There also may be multiple reasons (i.e., scientific, humanistic, educational, and artistic) to curate the aesthetically and culturally significant artifacts that often are found at these sites. Such artifacts merit special consideration for scientific reasons because of the wide variety of information that can be derived from them (Brown 1981:181–83).

Another problem in defining samples is our inability to predict the kinds of biases that future research will discover, even in the collections resulting from today's most carefully designed data collection strategies. We cannot predict the future, but we can evaluate the past and attempt to correct existing recognizable biases in the curated data bank. Such biases severely limit the kinds of research problems that currently can be addressed with collections, and it is likely that these limitations will become more profound over time. As discussed in chapter 5, periodic review and evaluation of collections are necessary to identify and correct biases so that collections management becomes responsive to new information and changing research needs. An important component of a review and evaluation process is comparison of the curated sample with the overall composition of the archaeological record.

For example, as we saw in chapter 2, material classes now considered "standard" data sources (e.g., botanical samples recovered via flotation and chipped stone debitage collected by screening) were not collected in the 1930s. Developments in archaeological practice now make it possible and routine to recover and interpret such materials. Reviews and evaluations of curated collections could highlight sites, time periods, and geographic areas that lack such data sources in the curated sample. Consequently, collections reviews can help stimulate and justify research into these areas, especially in the context of CRM studies.

A logical way to begin developing plans for better managing collections is to determine the nature of the sample now represented in curated collections. Unfortunately, the present sample is poorly known at the regional and national levels because of inaccessibility to collections (Dunnell 1984; Salwen 1981; Sullivan 1992a, 2001) and a general lack of concern by the archaeological profession. As repositories increasingly use information management technology, and as the In-

ternet provides new outlets for information dissemination about collections, we hope that increased accessibility will facilitate interest in and evaluation of the curated sample.

ENCOURAGING REPOSITORIES TO CURATE REPRESENTATIVE SAMPLES OF THE ARCHAEOLOGICAL RECORD

Comprehensive planning for representative data collection and curation requires well-considered input from several sources. The expertise of archaeological researchers and cultural resource managers is critical, and all plans must be in synch with repository policies. A strategic part of this coordination is to involve collections managers at the front end—that is, in making decisions about what to collect. This involvement is necessary to ensure that repositories will accept the desired range of collections and that these materials are appropriate for building data banks for continuing archaeological research.

Repository mission statements and collections management policies are essential ingredients for effective coordination of archaeological resource management activities, including shaping the curated sample into a data bank appropriate for long-term research needs. As we discussed in chapter 5, the mission statement establishes the long-term goals of a repository based on the types of collections it will curate. The mission statement considers geographic area, subject matter, and time period, as well as how the collections will be used (e.g., education, research, exhibition). Repository staff members then translate these general parameters into more specific policies for accepting and building collections (i.e., scope of collections, acquisitions, loans), as well as for other collection activities, such as research, exhibition, and deaccessioning (Malaro 1979; NPS 1990; Pearce 1996:67–68).

A good acquisition policy takes an *active* rather than *passive* approach to acquisitions (Burcaw 1997). With a passive approach, the repository merely decides what will be in its collections based on what it is offered. In contrast, active collecting means that a repository utilizes its long-term goals to make specific, conscious decisions about how its collections will grow and seeks to obtain those materials to meet those goals. For example, a repository may focus on the kinds of artifacts or specimens to be accepted, the level of

documentation required, or the kind of sites or projects from which collections can or should be accepted. An active approach allows an institution to exercise considerable control over what it acquires, as well as to apply some quality control over what is curated.

Archaeologists and agency managers should become familiar with the potential for collections management policies to assist in the long-term management of archaeological resources. Many archaeologists and agencies have long regarded curation as merely a storage problem, so they may overlook the logical links among project design, collecting strategy, long-term research value, and curation (see chapters 6 and 7). The critical parameters that control the kind of collections to be made, therefore, may be set without input from appropriate repositories, which are often contacted after collections are already made. When this happens, repositories are placed in the unflattering role of critics rather than partners because repository staffs are asked to deal with a collection on whose composition or condition they had no input.

Repositories are now developing active collections policies as standard museum practice. Academic-based and CRM-based archaeologists need to become active partners in this process (Sonderman 1996; Sullivan 1992a, 2001) because collections policies may be detrimental to future research and interpretation efforts if written by persons who are unfamiliar with the long-term needs of archaeological research and heritage management. It is also appropriate that when collections involve the cultural heritage of Native American tribes, the affiliated groups are involved in the decision making concerning repository policies and long-term planning strategies.

COORDINATED REGIONAL PLANNING

Given the regional variation in the archaeological record, it is logical to develop plans for collections growth and long-term research at the regional level. State plans for managing cultural resources, which are required by federal regulation, historically have not included curated collections. The accumulating data bank of curated collections in various repositories needs to be considered explicitly in such planning efforts. Again, planning for better collections management requires coordination between the agencies and bureaus that decide which sites are to be excavated, the archaeologists who make and use the

collections, the repositories that ultimately curate the materials, and the Native American tribes and other culture groups whose cultural heritage is represented by the collections.

One possible way to coordinate regional planning efforts is for statewide archaeological professional organizations to work with State Historic Preservation Offices and Tribal Historic Preservation Offices. The repositories, government entities, and the archaeologists with long-term research and collecting interests in specific regions would be brought together to conduct this planning. The repositories could solicit Native American involvement, perhaps through their Native American advisory groups. Representatives of federal programs having major influence in the regions also should be included. Input from these bureaus is necessary for coordination with their cultural resource management master plans.

The major goal of such regional task forces would be to draft complementary collections management policies among the repositories based in the region in order to shape the sample of the archaeological record that will be contained in curated collections. In some cases, interinstitutional agreements may be needed where there is overlap in the geographic areas covered by two or more museums. Such plans would neither require nor preclude designation of regional repositories (Marquardt 1977a; see chapter 3), because the plans would be regional in nature, not necessarily the repositories. Periodic review and revision of the plans and museum policies would also be necessary as collections grow and as archaeological knowledge expands and evolves. Such regional task forces could then have a positive impact on collections policies in general, especially as a wider constituency becomes aware of and involved with collections issues.

SUPPORT FOR CURATING
ARCHAEOLOGICAL COLLECTIONS

Earlier in this chapter, we discussed the importance of computer hardware and software to inventory and to provide remote access to archaeological collections, records, and reports. We presented the need to build up collections data banks and to create regional task forces to develop collections plans for the future. All of this requires support, including funding, professional and experienced staff, and adequate equipment and facilities.

Several aspects of archaeological curation require significant funding support, notably:

- Inspection of existing collections and any rehabilitation, conservation, and inventory work required
- Initial processing, inventory, and long-term care of new collections
- Creation and upkeep of repository space and appropriate facilities and equipment
- Professionally trained staff to manage and accomplish these tasks

Over the years, a number of different solutions have been proposed or implemented to meet the many needs of curation. Many nonprofit repositories that curate archaeological collections, such as university museums, historical societies, and city facilities, have had to seek support through their parent institutions. They also have had to expend considerable effort to obtain grants to fund various activities, such as exhibits, conservation, collection rehabilitation, and expansion of storage facilities (e.g., Magid 1991). Fortunately, some granting agencies have provided significant aid to these institutions, such as the National Science Foundation, the National Institute of Conservation, the National Endowment for the Humanities, and the Institute of Museum and Library Services. However, federal grants are usually not available for federal collections. Designating a repository prior to receiving a federal permit per ARPA and 36 CFR Part 79 implies, though does not ensure, that long-term funding was negotiated between an agency and repository prior to starting a project. Although not backed by legislation, many concerned archaeologists and curators advocate creating a line item for curation in each research or contract project budget (Acuff 1993; Ford 1977:25; Marquardt et al. 1982; McGimsey 1977:32) or hiding the costs of initial processing in field recovery (Thompson 1977:37).

Another solution initiated in the late 1970s and regularly adopted by U.S. repositories since then has been to charge fees to collection depositors, such as a federal agency or bureau, state agency, or contracting firm, for particular services (Marquardt 1977a; Moore 1994). (See table 8.2.)

These fees have proved to be useful ways to secure financial assistance for repositories that had previously provided such services for free. However, a recent informal survey of approximately ninety repositories (Childs 1998), including at least one in every state, reveals tremendous variation in the types of fees charged, the standard units on which the fees are charged, the criteria used to assess fees,

Table 8.2. Curation Fees: Some Key Points

Types of Service Fees Charged
- Entry or receiving (to review and process documentation on collection)
- One-time processing and long-term curation (often referred to as "in perpetuity")
- Processing (for cleaning, packaging, and/or cataloging to repository's standards)
- Annual (yearly maintenance)
- Rehabilitation or revitalization of existing collection
- Documentation (sometimes different from object collection)
- Oversized objects or individual objects
- Other (e.g., NAGPRA assessment, deaccessioning, short-term storage, special conservation, inspection according to 36 CFR Part 79)

Standard Units on which Fees Are Based
- Box measuring about one cubic foot (12 × 15 × 10")
- Box measuring 21 × 16 × 3"
- Unspecified box size
- Unspecified drawer size
- Hours of staff time in repository or field
- Linear inch for documentation

Principal Criteria Used to Assess Fees
- Conditions of curation agreement
- Comparison of fee structures of nearby repositories
- Evaluation of actual costs to process collections over long term (i.e., any combination of overhead, utilities, value of space, supplies, staff salaries, computer hardware and software, storage furniture, inflation)
- Evaluation of reasonable support for curation without causing collection owners to go elsewhere

Uses of Collected Fees
- Personnel costs to process collections upon deposit
- Costs of appropriate materials (e.g., shelving, boxing, computers)
- Repository overhead
- Meeting the standards of storage and collections care as required by 36 CFR Part 79
- Optimizing accessibility to collections, including small exhibits and publications

and the uses of the collected fees (table 8.2). Furthermore, the actual amounts of fees charged vary considerably within and between regions (table 8.3; Childs 1998). Some of this variation relates to local differences in salaries, cost of materials, utilities, and institutional affiliation (Futato 1996). The archaeologist who is preparing a project needs to be aware of the range of fees in a region. Trying to find the repository that charges the lowest fee may not be a good strategy, especially if that repository does not provide the full range of curatorial services presented in 36 CFR Part 79.

The informal survey also yielded information on the effects of curation fees on archaeological practice (table 8.4; Childs 1998). In the

Table 8.3. Range of Curation Fees in Regions of the United States in 1998

Region	Number of States	Range of Fees (minimum–maximum)
Northeast	12, including D.C. (5 without identified repositories that charge fees)	$37.63 per box–$250 per cubic foot
Southeast	11 (3 without identified repositories that charge fees)	$68 per cubic foot–$227 per "box"
Midwest	13 (4 without identified repositories that charge fees)	$70 per cubic foot–$360 to $400 per "standard box"
Intermountain	8	$60 per cubic foot–$560 per drawer; $33.75 per person day on a project
West	7	$150 per cubic foot–$1,080 per cubic foot; $33 per hour processing

field, sampling of some artifact types and noncultural materials is increasing to minimize costs per storage unit in a repository. Before and after the field, more and more archaeologists and contracting firms are paying attention to repository policies and standards to minimize costs. These findings need to be carefully considered because they can affect the future data bank of archaeological resources, especially if

Table 8.4. Effects of Curation Fees on Archaeological Practice

Effects on Field Techniques
- Considerably more sampling and culling is done in the field, though it is unclear whether these activities are well documented.
- The policies of some agencies and bureaus are changing to not require collection of all usual artifact classes during a project.
- Objects are not picked up during surface surveys, although they are documented by mapping and photography.
- More flotation is done in the field rather than bringing soil samples to the laboratory or repository.

Effects on the Receipt of Collections by a Repository
- Collections are in good condition upon arrival, minimizing initial processing costs.
- Noncultural items are culled.
- Collection owners are taking time to learn about repository facilities, curation agreements, and long-term collections care.
- On the negative side, boxes occasionally arrive overpacked to minimize costs.

sampling is not carefully planned and documentation of the decisions made is not carefully done.

Many repositories that charge fees now place a greater burden of initial processing on the archaeologist, collection owner, or donor (Harris 1993). The repository establishes strict requirements in its collections management policy on the acceptable condition of a collection upon receipt. These prerequisites often include prior cleaning, cataloguing and inventorying using the repository's standards, specific sizes and types of bags and storage boxes, complete documentation and related records, and initial conservation work. If these requirements are not met prior to depositing a collection, then the costs are borne by the collection maker and owner, not by the caretaker repository.

The use of state, regional, or national repositories is another broadscale solution to controlling curation costs (Bade and Lueck 1994; Marquardt 1977a; Marquardt et al. 1982; McGimsey and Davis 1977; Moore 1994; Trimble and Meyers 1991; Woosley 1992). Centralized facilities can minimize duplication of effort by sharing the costs of staff time and specialized expertise, materials, equipment, and facilities among the collection owners. Several states, such as Maryland, Maine, and Connecticut, have designated specific repositories to manage the collections from their states that are owned by state or federal agencies.

Consortia of federal agencies, state agencies, universities, tribes, and others also have been discussed to meet regional needs. Specific proposals have included building new repositories, renovating existing buildings (e.g., deactivated military warehouses and bunkers, buildings on the National Register of Historic Places), or using established, well-respected museums that only need additional support for existing staff and facilities (Chapman 1977; Ford 1977; Hester 1977; Thompson 1977). Some questions need resolution before the regional repository progresses very far (Chapman 1977; Hester 1977; Lindsay et al. 1980; McGimsey 1977):

- Who owns the collections and has the authority to loan, provide access to, and deaccession objects or collections?
- How would the various consortium members cover costs?
- Who would be in charge of and responsible for the various repository functions and services?
- Should a regional repository offer educational and public interpretation functions or just storage, conservation, and research functions?
- Who would own the equipment bought using grants?

- Will existing repositories be willing to give up their collections to a regional entity?

The costs of curating and making accessible millions of archaeological artifacts, records, and reports will not go away. The key is to control and distribute the costs among the responsible parties; increasingly this is being done. Archaeologists must have a clearer understanding of the costs involved and commit to budgeting curation and conservation activities into their projects. Happily, this essential commitment is happening more and more.

IS IT ALL WORTH IT?

We think it is all worth it! An equally compelling question is "Is it worth excavating, surveying, and managing archaeological sites if we do not properly curate the collections and associated documentation from those projects?" A well-made, well-documented, and well-curated collection such as the Chickamauga Basin collection, as noted in chapter 2, can provide fodder for numerous research projects, even if it was made over two generations ago and lacks material classes or information now routinely collected. We also have seen that it has taken the efforts of strong-minded and strong-willed archaeologists, repository staff, and heritage advocates to provide care for existing collections and to bring the curation crisis to national attention. Finally, we have seen that the crisis is far from over, but there is beginning to be some hope.

As more archaeologists learn about curation, as more repository staff members understand the multifaceted significance of the collections under their care, and as more people become aware of the irreplaceable representation of their heritage in collections, the number of advocates for quality care of collections grows and the collective voice becomes stronger. The ability to garner needed resources also will grow with this strengthened voice. To be strong and effective, all groups and individuals with interests in curated collections must respect each other's roles and views. They must attempt to work toward solutions to the crises that benefit all or that represent well-considered compromises.

Curated archaeological collections are highly significant pieces of the human past. We need to preserve that connection to peoples' heritage because it reminds us from where we came and who we are. But,

we cannot and should not save everything. That which we do decide to preserve represents our legacy to future generations. The composition of that legacy deserves our careful consideration and its care our best efforts. The curation crisis is much more than a storage problem. It's about what our progeny will inherit. How will they view *us* as caretakers of their heritage, from the field to the repository, and into the future?

APPENDIX

USEFUL INTERNET SITES RELATED TO CURATING ARCHAEOLOGICAL COLLECTIONS

The following list of Internet sites is not exhaustive or definitive. It is intended to help you start searching for other helpful information pertinent to your needs and to understand the range of diversity available on the Internet.

ARCHIVES AND RECORDS MANAGEMENT

- Council for the Preservation of Anthropological Records: archaeology .la.asu.edu/copar
- National Anthropological Archives: www.nmnh.si.edu/naa
- National Archives and Records Administration: www.nara.gov
- Northeast Document Conservation Center: www.nedcc.org
- Primer on Disaster Preparedness, Maintenance and Response for Paper-based Materials, National Park Service: www.cr.nps.gov/ csd/publications/primer/primintro.html

CAREER INFORMATION

- American Association of Museums Careers Information: www. aam-us.org/tis3b.htm
- Occupational Outlook Handbook for Archivists, Curators, Museum Technicians and Conservators: stats.bls.gov/oco/ocos065.htm

CONSERVATION

- Conservation Online (CoOL): palimpsest.stanford.edu
- Conserve O Grams (National Park Service): www.cr.nps.gov/csd/publications/index.htm
- International Center for the Study of the Preservation and Restoration of Cultural Property (ICCROM): www.iccrom.org
- Getty Conservation Institute: www.getty.edu/gci/conservation
- National Center for Preservation Technology and Training: www.ncptt.nps.gov
- American Institute for Conservation of Historic and Artistic Works: palimpsest.stanford.edu/aic
- South Carolina State Museum Conservation Library: www.museum.state.sc.us/Conservation/reference.htm

DEED OF GIFT FORM

- Center of Southwest Studies, Fort Lewis College: www.fortlewis.edu/acad-aff/swcenter/form-sw5.htm
- Division of Museums and History, Nevada Department of Museums: dmla.clan.lib.nv.us/docs/museums/reno/deed.htm
- Indiana University Oral History Research Center Deed of Gift: www.indiana.edu/~ohrc/deed.htm

DIGITAL ARCHIVING

- Archaeological Data Archive Project: csa.brynmawr.edu/web1/adap.html
- Arts and Humanities Data Service (U.K.), Managing Digital Collections: ahds.ac.uk/manage/manintro.html

EDUCATIONAL OPPORTUNITIES ON ARCHAEOLOGICAL CURATION AND CONSERVATION

- Managing Archeological Collections: An Online Course: www.cr.nps.gov/aad/curationcourse
- National Preservation Institute: www.npi.org
- Smithsonian Center for Materials Research and Education: www.si.edu/scmre/educate.html

- Cultural Resource Management Program, University of Victoria, Canada: www.uvcs.uvic.ca/crmp

FEDERAL EXPERTISE ON COLLECTIONS MANAGEMENT

- Department of the Interior Museum Property Policies and Standards: www.doi.gov/pam/mupol.html
- National Park Service Museum Management Program: www.cr.nps.gov/csd
- U.S. Army Corps of Engineers Mandatory Center of Expertise for the Curation and Management of Archeological Collections: www.mvs.usace.army.mil/engr/curation/home.htm
- Guidelines for the Field Collection of Archaeological Materials and Standard Operating Procedures for Curating Department of Defense Collections: www.denix.osd.mil/denix/Public/ES-Programs/Conservation/Legacy/Collguide/collguide.pdf

GRANTS AND FUNDING OPPORTUNITIES

- Institute of Museum and Library Services: www.imls.gov/
- National Endowment for the Humanities: www.neh.fed.us/
- National Science Foundation: www.nsf.gov
- Native American Graves Protection and Repatriation Act Grants: www.cr.nps.gov/aad/nagpra.htm

GRAY LITERATURE AND ONLINE PUBLICATIONS

- National Archeological Database—Reports Module: www.cr.nps.gov/aad/nadb.htm
- Digital Imprint (UCLA): www.sscnet.ucla.edu/ioa/labs/digital/imprint/imprint.html
- Site and Survey Reports from ArchNet: archnet.uconn.edu/sites/

HISTORIC PRESERVATION LAWS, REGULATIONS, AND STANDARDS

- Federal Laws, Regulations, and Standards: www.cr.nps.gov/linklaws.htm

- State Historic Preservation Legislation Database: ncsl.org/programs/arts/statehist.htm

INTELLECTUAL PROPERTY RIGHTS

- Copyright and Intellectual Property, Conservation Online: palimpsest.stanford.edu/bytopic/intprop
- Intellectual Property Mall, Franklin Pierce Law Center: www.ipmall.fplc.edu
- A Museum Guide to Copyright and Trademark, American Association of Museums: www.aam-us.org/museum-guide-toc.htm

MUSEUM ORGANIZATIONS

- American Association of Museums: www.aam-us.org/index.htm
- The International Council of Museums: www.icom.org

ONLINE COLLECTIONS AND CATALOGS

- Archaeological Research Institute, Arizona State University: archaeology.la.asu.edu/collections.asp
- Zooarchaeology Comparative Collection Databases, Florida Museum of Natural History: www.flmnh.ufl.edu/databases/zooarch/intro.htm
- Prehistoric Ceramics from Southern New England: archnet.uconn.edu/topical/ceramic/windsor/windsor.html
- Ohio Historical Society Online Collection Catalogs: www.ohiohistory.org/webpac-bin/wgbroker?new+-access+top

ONLINE EXHIBITS

- Illinois State Museum: www.museum.state.il.us/exhibits
- Frank H. McClurg Museum, University of Tennessee: mcclurgmuseum.utk.edu/permex/archael/archael.htm
- National Museum of Natural History, Anthropology: www.nmnh.si.edu/departments/anthro.html/anexhib.html
- Peabody Museum of Archaeology and Ethnology: www.peabody.harvard.edu/exhibitions.html

• University of Pennsylvania Museum: www.upenn.edu/museum/ Collections/ourwebexhibits.html

POLICIES (I.E., ACCESS AND USE, COLLECTIONS MANAGEMENT, DEACCESSION, FEES, LOANS)

• Alexandria Archaeology (VA) Collections Policy: ci.alexandria.va .us/oha/archaeology/ar-coll-policy.html
• American Museum of Natural History: anthro.amnh.org/ anthropology/collections/access_form.htm
• Archaeological Collections Facility, Sonoma State University: www.sonoma.edu/projects/asc/acf/default.html
• Florida Museum of Natural History Collections Policy: www.flmnh.ufl.edu/admin/collect1.htm
• Kelsey Museum, University of Michigan: www.umich.edu/ ~kelseydb/MuseumPolicies/policies.html
• Office of Archaeological Services, University of Alabama: Museums<bama.ua.edu/~cmeyer/curation.htm
• Oklahoma State University Museum Collections Policy: www.ok-state.edu/osu_policies/1-0119.html
• South Dakota State Historical Society, Archaeological Research Center: www.sdsmt.edu/wwwsarc/repos-guide/index.html
• Tehama County Museum, CA Collections Policy: www.tco.net/ tehama/museum/tcmnewpolicy.htm
• Texas Archeological Research Laboratory, University of Texas at Austin: www.utexas.edu/research/tarl
• University of Alaska Museum, Archaeology Collections: zorba .uafadm.alaska.edu/museum/archeo/P&P.html

STATE CURATION GUIDELINES

• California (.pdf file):www.chris.ca.gov/PUBLICATIONS/cura-tion_manual/curation_guide_1993.pdf
• Maryland: www2.ari.net/mdshpo/xmht-ftp.html
• North Carolina: www.arch.dcr.state.nc.us/curation.htm
• Council of Texas Archeologists, the Accreditation and Review Council: www.c-tx-arch.org/cta ARC/ARC.html

 REFERENCES

Acuff, Lysbeth
1993 Collections Management: An Ethical Responsibility. *The Grapevine* 3(3):3–4.

Alexander, Edward, David R. Brigham, John W. Durel, Ruth Helm, and Sally Gregory Kohlstedt
1992 *Mermaids, Mummies, and Mastodons: The Emergence of the American Museum.* American Association of Museums, Washington, D.C.

Bade, Mary J., and Rhonda R. Lueck
1994 *An Archaeological Curation-Needs Assessment for the U.S. Army Corps of Engineers, Mobile District.* U.S. Army Corps of Engineers, St. Louis District, Technical Center of Expertise in Archaeological Curation and Collections Management, Technical Report No. 3.

Bell, Jan
1990 Getting Off to a Good Start: New Relationships between Agencies and Archaeological Repositories under the New CFR. *American Society for Conservation Archaeology Report* 17(2):7–13.

Bender, Susan, and George S. Smith (eds.)
2000 *Teaching Archaeology in the Twenty-first Century.* Society for American Archaeology, Washington, D.C.

Browman, David L., and Douglas R. Givens
1996 Stratigraphic Excavation: The First "New Archaeology." *American Anthropologist* 98(1):80–95.

Brown, James A.
 1981 The Potential of Systematic Collections for Archaeological Research. In *The Research Potential of Anthropological Museum Collections*, Anne-Marie Cantwell, James B. Griffin, and Nan A. Rothschild (eds.), pp. 65–77. Annals of the New York Academy of Science, Vol. 376. New York Academy of Sciences, New York.

Buck, Rebecca A., and Jean A. Gilmore (eds.)
 1998 *The New Museum Registration Methods*, 3d ed. American Association of Museums, Washington, D.C.

Burcaw, G. Ellis
 1997 *Introduction to Museum Work.* AltaMira Press/American Association for State and Local History, Walnut Creek, California.

Bush, Kent
 1996 The Fall and Rise of Fort Vancouver. *Common Ground* 1(2):46–49.

Butler, Patrick H., III
 Obligations in Organizing a Museum. In *Organizing Your Museum:*
 1989 *The Essentials*, S. K. Nichols, compiler, pp. 1–8. Technical Information Service, American Association of Museums, Washington, D.C.

Canouts, Veletta
 1992 Computerized Information Exchanges on the Local and National Levels in USA. In *Sites and Monuments. National Archaeological Records*, C. Larsen (ed.), pp. 23–47. National Museum of Denmark, Copenhagen.

Cantwell, Anne-Marie, James B. Griffin, and Nan A. Rothschild (eds.)
 1981 *The Research Potential of Anthropological Museum Collections.* Annals of the New York Academy of Sciences, Vol. 376. New York Academy of Sciences, New York.

Carnell, Clarisse, and Rebecca Buck
 1998 Acquisitions and Accessioning. In *The New Museum Registration Methods*, Rebecca A. Buck and Jean A. Gilmore (eds.), pp. 157–65. American Association of Museums, Washington, D.C.

Carnett, Carol
 1991 *Legal Background of Archeological Resources Protection.* Technical Brief No. 11, Archeological Assistance Division, National Park Service, U.S. Department of the Interior, Washington, D.C.

Carroll, Mary S. (ed.)
 2002 *Delivering Archaeological Information Electronically.* Society for American Archaeology, Washington, D.C.

Chapman, Carl
 1977 Cultural-Environmental Center Physical Facilities and Management Funding. In *Regional Centers in Archaeology: Prospects and Problems,* W. Marquardt (ed.), pp. 16–17. Missouri Archaeological Society, Columbia.

Chenhall, Robert, and David Vance
 1988 *Museum Collections and Today's Computers.* Greenwood Press, Westport, Connecticut.

Childs, S. Terry
 1995 The Curation Crisis—What's Being Done? *Federal Archeology* 7(4):11–15.
 1996 Collections and Curation into the 21st Century. *Common Ground* 1(2):25.
 1998 The Adoption and Use of Curation Fees across the United States. Paper presented at the Second Conference on Partnerships for Federally-Associated Collections, San Diego, California.
 1999 Contemplating the Future: Deaccessioning Federal Archaeological Collections. *Museum Anthropology* 23(2):38–45.
 2000 SSA Committee on Curation. Who We Are, Our Goals, and Our Issues. *SAA Archaeological Record* 1(2): 10–11, 37.
 2002 Committee on Curation Update: Implementing SAA Ethic #7, Records and Preservation. *The Archaeological Record* 2(3):6.

Christenson, Andrew L.
 1979 The Role of Museums in Cultural Resources Management. *American Antiquity* 44(1):161–63.

Conn, Steven
 1998 *Museums and Intellectual Life, 1876–1926.* University of Chicago Press, Chicago.

Cowan, Suzanne
 1998 Inventory. In *The New Museum Registration Methods,* Rebecca A. Buck and Jean A. Gilmore (eds.), pp. 117–19. American Association of Museums, Washington, D.C.

Crass, David C.
 1991 *Savannah River Archaeological Research Program—Guide to Curation Procedures.* Technical Report Series #14, Savannah River Archaeological Research Program, South Carolina Institute of Archaeology and Anthropology, University of South Carolina.

Cronyn, Janey M.
1990 *The Elements of Archaeological Conservation.* Routledge, London.

Damadio, Stephanie
1999 Linking the Past to the Future—Museum Collections and the Bureau of Land Management. *CRM* 22(4):32–34.

Department of the Interior
1993 *Museum Property Handbook, Volume I: Preservation and Protection of Museum Property.* U.S. Department of the Interior, Washington, D.C.
1997 *Policies and Standards for Managing Museum Collections.* Departmental Manual Part 411. U.S. Department of the Interior, Washington, D.C.

Dunnell, Robert
1984 The Ethics of Archaeological Significance Decisions. In *Ethics and Values in Archaeology,* Ernestene Green (ed.), pp. 62–74. Free Press, New York.

Ellis, Judith (ed.)
1993 *Keeping Archives.* D. W. Thorpe, Victoria, Australia.

Fairbanks, Charles
1970 What Do We Know Now That We Did Not Know in 1938? *Southeastern Archaeological Conference Bulletin* 13:40–45.

Farnsworth, Kenneth, and Stuart Struever
1977 Ideas on Archaeological Curation and Its Role in Regional Centers. In *Regional Centers in Archaeology: Prospects and Problems,* W. Marquardt (ed.), pp. 13–15. Missouri Archaeological Society, Columbia.

Ferguson, Bobbie, and Myra Giesen
1999 Accountability in the Management of Federally Associated Archeological Collections. *Museum Anthropology* 23(2):19–33.

Ford, Richard I.
1977 *Systematic Research Collections in Anthropology: An Irreplaceable National Resource.* Peabody Museum, Harvard University for the Council for Museum Anthropology, Cambridge, Massachusetts.
1980 A Three Part System for Storage of Archaeological Collections. *Curator* 23(1):55–62.

Fowler, Donald, and Douglas Givens
1995 The Records of Archaeology. In *Preserving the Anthropological Record,* 2d ed., Sydel Silverman and Nancy J. Parezo (eds.),

pp. 97–106. Wenner-Gren Foundation for Anthropological Research, New York.

Fowler, Donald, Nancy Parezo, and Mary Elizabeth Ruwell
1996 Wealth Concealed. *Common Ground* 1(2):31–33.

Fowler, Melvin L.
1985 A Brief History of Illinois Archaeology. *Illinois Archaeology, Bulletin No. 1, Revised*, pp. 3–11. Illinois Archaeological Survey, Springfield.

Friedman, Ed, and Brit A. Storey
1999 CRM and the Bureau of Reclamation. *CRM* 22(4):45–47.

Futato, Eugene M.
1996 A Case for Partnerships. *Common Ground* 1(2):50–53.

GAO (General Accounting Office)
1987 *Problems Protecting and Preserving Federal Archeological Resources.* RCED-88-3. General Accounting Office, Washington, D.C.

Glassow, Michael
1977 Issues in Evaluating the Significance of Archaeological Resources. *American Antiquity* 43(3):413–20.

Greene, Mary W.
1985 Report: National Science Foundation Anthropology Program; Systematic Anthropological Collections. *Council for Museum Anthropology Newsletter* 9(4):2–4.

Griset, Suzanne, and Marc Kodack
1999 *Guidelines for the Field Collection of Archaeological Materials and Standard Operating Procedures for Curation of Department of Defense Archaeological Collections.* Legacy Project No. 98-1714. Mandatory Center of Expertise for the Curation and Management of Archaeological Collections. U.S. Army Corps of Engineers, St. Louis District.

Guthe, Carl E.
1957 *So You Want a Good Museum.* American Association of Museums, Washington, D.C.
1959 *The Management of Small History Museums.* American Association for State and Local History, Nashville.

Harris, E. Jeanne
1993 The Cost of Curation Is Going Up. *The Grapevine* 3(3):4–5.

Hester, James
1977 Specialized and Generalized Models of Regional Centers. In *Regional Centers in Archaeology: Prospects and Problems,*

W. Marquardt (ed.), pp. 4–10. Missouri Archaeological Society, Columbia.

Hitchcock, Ann
 1994 Archeological and Natural Resource Collections of the National Park Service: Opportunities and Threats. *Curator* 37(2):122–28.

Hoopes, John W.
 1998 The Online Lab Manual: Reference Collections on the Web. *Society for American Archaeology Bulletin* 16(5):17–19, 39.

International Council of Museums
 1987 Code of Professional Ethics. In *ICOM Statues/Code of Professional Ethics*. ICOM, Maison de l'Unesco, Paris.

Jacobson, Claudia
 1998 Preparation. In *The New Museum Registration Methods*, Rebecca A. Buck and Jean A. Gilmore (eds.), pp. 121–25. American Association of Museums, Washington, D.C.

Jelks, Edward B.
 1989 Curation of Federal Archeological Collections in the Southwest: A Status Report. Paper presented in symposium entitled, "Using and Abusing Archeological Collections," at Preservation Challenges for the 1990s: A Conference for Public Officials, June 5–7, Washington, D.C.

Jennings, Paulla Dove
 1996 Objects of Life. *Common Ground* 1(2):39–45.

Jessup, W. C.
 1995 Pest Management. In *Storage of Natural History Collections: A Preventive Conservation Approach*, C. Rose, C. Hawks, and H. Genoways (eds.). Society for the Preservation of Natural History Collections, Iowa City.

Jonaitis, Aldona
 1992 Franz Boas, John Swanton, and the New Haida Sculpture at the American Museum of Natural History. In *Early Years of Native American Art History: Scholarship and Collecting*, Janet Catherine Berlo (ed.), pp. 22–61. University of Washington Press, Seattle.

Katz, Herbert, and Marjorie Katz
 1965 *Museums, U.S.A.: A History and Guide*. Doubleday, Garden City, New Jersey.

Kenworthy, Mary Ann, Eleanor M. King, Mary Elizabeth Ruwell, and Trudy Van Houten
 1985 *Preserving Field Records: Archival Techniques for Archaeologists and Anthropologists*. University Museum, University of Pennsylvania, Philadelphia.

King, Mary Elizabeth
1980 Curators: Ethics and Obligations. *Curator* 23(1):10–18.

King, Thomas
1998 *Cultural Resource Law and Practice.* AltaMira Press, Walnut Creek, California.

King, Thomas, Patricia Hickman, and Gary Berg
1977 *Anthropology in Historic Preservation.* Academic Press, New York.

Krakker, James, David Rosenthal, and Deborah Hull-Walski
1999 Managing a Scholarly Resource: Archaeological Collections at the National Museum of Natural History. *Museum Anthropology* 23(2):9–18.

Lee, Ronald
1970 *The Antiquities Act of 1906.* National Park Service, Washington, D.C.

Lewis, Thomas M. N., and Madeline D. Kneberg
1946 *Hiwassee Island: An Archaeological Account of Four Tennessee Indian Peoples.* University of Tennessee Press, Knoxville.

Lewis, Thomas M. N., and Madeline Kneberg Lewis
1995 Appendix C: Manual of Field and Laboratory Techniques Employed by the Division of Anthropology, University of Tennessee, Knoxville, Tennessee, in Connection with the Investigation of Archaeological Sites within the TVA Dam Reservoirs. In *The Prehistory of the Chickamauga Basin in Tennessee*, 2 vols. T. M. N. Lewis and M. K. Lewis, compiled and edited by L. P. Sullivan, pp. 603–58. University of Tennessee Press, Knoxville.

Lewis, T. M. N., Madeline Kneberg Lewis, and Lynne P. Sullivan
1995 *The Prehistory of the Chickamauga Basin in Tennessee*, 2 vols. Edited and compiled by L. P Sullivan. University of Tennessee Press, Knoxville.

Lindsay, Alexander J., Jr., and Glenna Williams-Dean
1980 Artifacts, Documents, and Data: A New Frontier for American Archaeology. *Curator* 23(1):19–29.

Lindsay, Alexander J., Jr., Glenna Williams-Dean, and Jonathan Haas
1979 *The Curation and Management of Archaeological Collections: A Pilot Study.* Publication PB-296. National Technical Information Service, Springfield, Virginia.
1980 *The Curation and Management of Archaeological Collections: A Pilot Study.* Cultural Resource Management Series. U.S. Department of the Interior, Heritage Conservation and Recreation Service, Washington, D.C.

Lipe, William
 1974 A Conservation Model for American Archaeology. *The Kiva*
 39:213–45.

Lipe, William, and Charles Redmond
 1996 Conference on "Renewing our National Archaeological Pro-
 gram." *Society for American Archaeology Bulletin* 14(4):14–17.

Lynott, Mark J., David G. Anderson, Glen H. Doran, Ricardo J. Elia, Maria
Franklin, K. Anne Pybum, Joseph Schuldenrein, and Dean R. Snow
 1999 Teaching Archaeology in the 21st Century: Thoughts on Gradu-
 ate Education. *Society for American Archaeology Bulletin*
 17(1):21–22.

Lyon, Edwin A.
 1996 *A New Deal for Southeastern Archaeology.* University of Al-
 abama Press, Tuscaloosa.

Magid, Barbara
 1991 *Buried in Storage: The Alexandria Archaeology Collections
 Management Project.* American Association for State and Local
 History Technical Leaflet #178. American Association for State
 and Local History, Nashville, Tennessee.

Malaro, Marie C.
 1979 Collections Management Policies. *Museum News* 58(2):57–61.
 1998 *A Legal Primer on Managing Museum Collections,* 2d ed.
 Smithsonian Institution Press, Washington, D.C.
 1994 *Museum Governance: Mission, Ethics, Policy.* Smithsonian In-
 stitution Press, Washington, D.C.

Marquardt, William H.
 1977a Epilogue. *Regional Centers in Archaeology: Prospects and
 Problems,* W. Marquardt (ed.). Missouri Archaeological Soci-
 ety, Columbia.
 1977b Prospects for Regional Computer-Assisted Archaeological In-
 formation Retrieval. *Regional Centers in Archaeology:
 Prospects and Problems,* W. Marquardt (ed.), pp. 11–12. Mis-
 souri Archaeological Society, Columbia.

Marquardt, William H., Anta Montet-White, and Sandra C. Scholtz
 1982 Resolving the Crisis in Archaeological Collections Curation.
 American Antiquity 47(2):409–18.

McGimsey, Charles
 1977 Discussion. In *Regional Centers in Archaeology: Prospects and
 Problems,* W. Marquardt (ed.), p. 32. Missouri Archaeological So-
 ciety, Columbia.

McGimsey, Charles, and Hester Davis
1977 *The Management of Archeological Resources—The Airlie House Report.* Special Publication of the Society for American Archaeology, Washington, D.C.

McKeown, C. Timothy, Amanda Murphy, and Jennifer Schansberg
1998 Complying with NAGPRA. In *The New Museum Registration Methods*, Rebecca A. Buck and Jean A. Gilmore (eds.), pp. 311–19. American Association of Museums, Washington, D.C.

McManamon, Francis P.
1996 The Long View. *Common Ground* 1(2):2.

McManamon, Francis P., and Kathleen Browning
1999 Department of the Interior's Archeology Program. *CRM* 22(4):19–21.

McW.Quick, Polly (ed.)
1985 *Proceedings: Conference on Reburial Issues.* Society for American Archaeology and the Society of Professional Archaeologists, Washington, D.C.

Meyers, Thomas B., and Michael K. Trimble
1993 *Archaeological Curation-Needs Assessment for Fort Sill, Oklahoma, Fort Gordon, Georgia, Vandenberg Air Force Base, California, Camp Pendleton Marine Corps Base, California, and Naval Air Weapons Station, China Lake, California.* U.S. Army Corps of Engineers, St. Louis District, Technical Center of Expertise in Archaeological Curation and Collections Management, Technical Report No. 1.

Milner, George R.
1987 Contract Excavations, Collections Management, and Academic Archaeology. Paper presented at the annual meeting of the American Association for the Advancement of Science, Chicago.

Moore, Rick
1994 *Preserving Traces of the Past: Protecting the Colorado Plateau's Archaeological Heritage.* Grand Canyon Trust, Flagstaff, Arizona.

Morris, Martha
1998 Deaccessioning. In *The New Museum Registration Methods*, Rebecca A. Buck and Jean A. Gilmore (eds.), pp. 167–76. American Association of Museums, Washington, D.C.

Nason, James
1999 Traditional Roots, Modern Preservation. *Common Ground* Fall:20–25.

National Institute for the Conservation of Cultural Property
1984 *Ethnographic and Archaeological Conservation in the United States*. NICC, Washington, D.C.

National Park Service
1990 Chapter 2: Scope of Museum Collections, *Museum Handbook*, Part I, Museum Collections, National Park Service, Revised 1990.
1990 36 CFR Part 79, Curation of Federally-Owned and Administered Archeological Collections. *Federal Register* 55(177):37616–39.
1998 *Bureau Museum Property Management Summary Report, FY1998*. On file with the Department of the Interior Museum Management Program, Washington, D.C.
2000 NPS Director's Order #24: NPS Museum Collections Management. On file with the Policy Office, National Park Service. www.nps.gov/policy/DOrders/DOrder24.html.

Nelson, Margaret C., and Brenda Shears
1996 From the Field to the Files: Curation and the Future of Academic Archeology. *Common Ground* 1(2):35–37.

New York Archaeological Council
1994 *Standards for Cultural Resource Investigations and the Curation of Archaeological Collections*. New York Archaeological Council, Rochester.

New York State Association of Museums
1974 *The Ethics and Responsibilities of Museums with Respect to the Acquisition and Disposition of Collection Materials*. New York State Association of Museums, Troy.

Nichols, Susan K. (comp.)
1989 *Organizing Your Museum: The Essentials*. Technical Information Service, American Association of Museums, Washington, D.C.

Odegaard, Nancy
2000 Collections Conservation: Some Current Issues and Trends. *CRM* 23(5):38–41.

Parezo, Nancy J., and Ruth J. Person
1995 Saving the Past: Guidelines for Individuals. In *Preserving the Anthropological Record*, 2d ed., Sydel Silverman and Nancy J. Parezo (eds.), pp. 161–78. Wenner-Gren Foundation for Anthropological Research, New York.

Pearce, Susan M.
1996 *Archaeological Curatorship*. Smithsonian Institution Press, Washington, D.C.

Peebles, Christopher, and Patricia Galloway
 1981 Notes from Underground: Management from Excavation to Cu-
 ration. *Curator* 24(4):225–51.

Puglia, Steven
 1999 Creating Permanent and Durable Information: Physical Media
 and Storage Information. *CRM* 22(2):25–27.

Ruwell, Mary Elizabeth
 1995 The Physical Preservation of Anthropological Records. In *Pre-
 serving the Anthropological Record*, 2d ed., Sydel Silverman and
 Nancy J. Parezo (eds.), pp. 97–106. Wenner-Gren Foundation for
 Anthropological Research, New York.

Salwen, Bert
 1981 Collecting Now for Future Research. *The Research Potential of
 Anthropological Museum Collections*, Anne-Marie E. Cantwell,
 James B. Griffin, and Nan A. Rothschild (eds.), pp. 567–74. An-
 nals of the New York Academy of Sciences, Vol. 376. New York
 Academy of Sciences, New York.

Scholtz, Sandra, and R. G. Chenhall
 1976 Archaeological Data Banks in Theory and Practice. *American
 Antiquity* 41(1):89–96.

Scoville, Douglas
 1977 Regional Center: Opportunities for Federal-Institutional Part-
 nership in Cultural Resources Management. In *Regional Cen-
 ters in Archaeology: Prospects and Problems*, W. Marquardt
 (ed.), pp. 23–28. Missouri Archaeological Society, Columbia.

Sease, Catherine
 1994 *A Conservation Manual for the Field Archaeologist*, 3d ed. Ar-
 chaeological Research Tools, Volume 4, Institute of Archaeol-
 ogy, University of California, Los Angeles.

Segal, Terry
 1998 Marking. In *The New Museum Registration Methods*, Rebecca
 A. Buck and Jean A. Gilmore (eds.), pp. 65–78. American Asso-
 ciation of Museums, Washington, D.C.

Shaffer, Gary, and Elizabeth Cole
 1994 *Standards and Guidelines for Archeological Investigations in
 Maryland*. Maryland Historical Trust Technical Report, #2.
 Maryland Historical Trust, Crownsville.

Silverman, Sydel, and Nancy J. Parezo (eds.)
 1995 *Preserving the Anthropological Record*, 2d ed. Wenner-Gren
 Foundation for Anthropological Research, New York.

Society for American Archaeology Curation Task Force
 1993 *Urgent Preservation Needs for the Nation's Archaeological Collections, Records, and Reports.* On file at the Society for American Archaeology, Washington, D.C.

Society for Historical Archaeology
 1993 Standards and Guidelines for the Curation of Archaeological Collections. *Society for Historical Archaeology Newsletter* 26(4).

Sonderman, Robert C.
 1996 Primal Fear: Deaccessioning Collections. *Common Ground* 1(2):27–29.

Squier, Ephraim G., and E. H. Davis
 1848 *Ancient Monuments of the Mississippi Valley.* Smithsonian Contributions to Knowledge, vol. 1. Smithsonian Institution, Washington, D.C.

Sullivan, Lynne P.
 1991 Museum Records and the History of Archaeology. *Bulletin of the History of Archaeology* 1(2):4–12.
 1992a *Managing Archaeological Resources from the Museum Perspective.* Technical Brief No. 13, Archeological Assistance Division, National Park Service, Department of the Interior, Washington, D.C.
 1992b Arthur C. Parker's Contributions to New York State Archaeology. *Bulletin of the New York State Archaeological Association* 104:1–8.
 1995 Foreword. In *The Prehistory of the Chickamauga Basin in Tennessee*, vol. 1. Thomas M. N. Lewis and Madeline D. Kneberg Lewis, compiled and edited by Lynne P. Sullivan, pp. xv–xxi. University of Tennessee Press, Knoxville.
 1999 Madeline Kneberg Lewis: Leading Lady of Tennessee Archaeology. In *Grit-Tempered: Early Women in Southeastern United States Archaeology*, Nancy M. White, Lynne P. Sullivan, and Rochelle Marrinan (eds.), pp. 57–91. University Press of Florida, Gainesville.
 2001 The Curation Dilemma: A Mutual Problem for Research and Resource Management. In *Protecting the Archaeological Heritage of America*, Robert Drennan and Santiago Mora (eds.), pp. 90–98. Society for American Archaeology, Washington, D.C.

Swain, Lynn
 1998 Storage. In *The New Museum Registration Methods*, Rebecca A. Buck and Jean A. Gilmore (eds.), pp. 109–19. American Association of Museums, Washington, D.C.

Terrell, John
1979 What Is a Curator? *Field Museum Bulletin* 50(4):16–17.

Thompson, Raymond
1977 Discussion. In *Regional Centers in Archaeology: Prospects and Problems*, W. Marquardt (ed.), pp. 33–37. Missouri Archaeological Society, Columbia.
2000 The Crisis in Archaeological Collections Management. *CRM* 23(5):4–6.

Trimble, Michael K., and Thomas B. Meyers
1991 *Saving the Past from the Future: Archaeological Curation in the St. Louis District*, U.S. Army Corps of Engineers, St. Louis District.

Vogt-O'Connor, Diane
1996 Care of Archival Digital and Magnetic Media. *Conserve O Gram* 19/20.
1997 Caring for Photographs: General Guidelines. *Conserve O Gram* 14/4.
1998 Care of Color Photographs. *Conserve O Gram* 14/6.
1999 Archives—A Primer for the 21st Century. *CRM* 22(2):4–8.

Vogt-O'Connor, Diane, and Dianne van der Reyden
1996 Storing Archival Paper-Based Materials. *Conserve O Gram* 19/15.

Warren, Winonah
1991 A Model Cultural Center at Pojoaque Pueblo. *CRM* 14(5):3–5.

White, Nancy M., Lynne P. Sullivan, and Rochelle Marrinan (eds.)
1999 *Grit-Tempered: Early Women in Southeastern United States Archaeology.* University Press of Florida, Gainesville.

Willey, Gordon, and Jeremy Sabloff
1977 *A History of American Archaeology.* Freeman, San Francisco.

Wilson, Ronald
1999 Interior's Museum Collections—Your Heritage. *CRM* 22(4):22–23.

Wilsted, Thomas, and William Nolte
1991 *Managing Archival and Manuscript Repositories.* Archival Fundamentals Series. Society of American Archivists, Chicago.

Woosley, Anne
1992 Future Directions: Management of the Archaeological Data Base. In *Quandaries and Quests: Visions of Archaeology's Future*, LuAnn Wandsnider (ed.), pp. 147–59. Center for Archaeological Investigations, Occasional Paper No. 20. Southern Illinois University, Carbondale.

INDEX

AAM. *See* American Association of Museums
academic archaeologist, 112
academic repository, 47–48, 52
access, collection: in academic repository, 47–48; for destructive analysis, 101–2; in government repository, 49; locating collection, 98–99; and NAGPRA compliance, 75; older collection, 98; on-site, 100; photographs, 76; problems with, 35–36, 74; 97–98; reasons for, 51; recent progress in, 43–44; through loans, 75, 100–101; use of inventory control/data management for, 71, 74. *See also* access, electronic
access, electronic: database, 44, 104–6; Internet, 106–8. *See also* access, collection
accession number, 62
accession records, 62
accessioning, 61–62
accessions register, 62
accountability, 3, 10, 21, 35–36
acquisition: definition of, 60; for long-term curation, 94–96; policy elements, 60–61

American Association of Museums (AAM), 41, 76, 124
American Indian, research on, 8
American Museum of Natural History, 7, 8, 9
Ancient Monuments of the Mississippi Valley (Squier & Davis), 8
antiquarian collection, 2
Antiquities Act of 1906, 9, 18
archaeological collection: difference from antiquarian collection, 2; importance of, 3; types of material objects/records in, 2
archaeological collections, current status of, 21; conservation ethic and, 23–24; federal legislation/policy and, 24–28, 26; historic preservation movement and, 23; Native American concerns and, 24
archaeological research: museum-based, 7–9; university-based, 9–10, 80
archaeology chronology, museology roots of, 5–6
Archeological and Historic Preservation Act (AHPA) of 1974, 24–25, 27

Archeological Resources Protection
 Act (ARPA) of 1979, 25, 40, 60,
 80, 82
archives, 50
archivist, 55, 56
Army Corps of Engineers, 34;
 assessment of federal collections
 by, 42–43; project vs. curation
 expenditures by, 27; reservoir
 salvage by, 18
ARPA. *See* Archeological Resources
 Protection Act (ARPA) of 1979
artifact container, 68
associated records management,
 36–38
audio-/videotape storage, 70, 89, 90

Boas, Franz, 7, 8
Bureau of American Ethnology
 (BAE), 8
Bureau of Land Management, 49
Bureau of Land Reclamation, 18

catalog/identity number, 63–64
cataloging, 63–64, 76
Ceramic Repository for the Eastern
 United States, 10
Charleston Museum, 6
Chickamauga Project (case study):
 artifact disposition, 13–14, 28;
 collections/records curation,
 14–15, 70; example of data
 available from, 16–17; extent of
 survey/excavation, 13; legacy of,
 12–13, 16; work force for, 13, 14,
 15
classification scheme: attribute-
 based system, 15; development
 of, 11; pottery typology, 11
Cole, Fay-Cooper, 10, 15
collection, as representative of
 archaeological record, 108–11
collection strategy: for noncultural

sample, 84; in project design, 79,
 82
collections manager, 54, 55, 56
condition report, 61–62
conservation, 66–67; definition of,
 51; ethics of, 23–24; in field,
 84–85; in laboratory, 85, 87, 88;
 of long-term collection, 96
conservator, 55, 56
continuing loan, 75
CoPAR. *See* Council for the
 Preservation of Anthropological
 Records
copyright, 76
Council for the Preservation of
 Anthropological Records
 (CoPAR), 44, 121
Council of Texas Archeologists, 41
cultural resource management
 (CRM), 20, 29, 89, 92, 110, 112
*Cultural Resources—Problems
 Protecting and Preserving Federal
 Archeological Resources*, 25
curation: accountability in, 3, 10,
 21; crisis in, 1, 23 (*see also*
 curation, elements of crisis in);
 definition of, 2–3; impotence of,
 2; lack of training in, 1–2, 108;
 marginalization of, 11–12, 108; as
 process, 1, 3; recent progress in,
 42–44
curation, concerns about future of:
 access, 103–4; curating
 representational samples, 111–12;
 database access, 104–6; funding,
 113–18; Internet access, 106–8,
 107; preserving representative
 samples, 108–11; regional
 planning coordination, 112–13;
 using collections, 108
curation, elements of crisis in,
 29–30;
 accountability/accessibility,
 35–36; associated records

management, 36–38; costs, 34–35; deaccessioning, 39–40; looting/illicit trading of artifacts, 39; management/care standards, 32–33; national curation initiative, 41–42; Native Americans concerns, 38–39; ownership, 29–31; personal responsibilities, 33–34; repository certification, 40–41
curation, history of: curiosity cabinet, 6; early federal programs, 11–12 (see also Chickamauga Basin Project); making vs. curating collections, 19–20; move from museum to university, 9–10; museum era, 5–9; New Archaeology, 19; postwar construction boom, 17–18; world's fairs, 6–7
curation, long-term: acquisition decisions for, 94–96; acquisition policy/procedure for, 94; fees for, 27, 92, 93, 95; locating appropriate repository for, 92–93; preparation/delivery of, 96–97; proposed repository standards for, 32
curation agreement, 81, 88–89, 95–96
curation costs, 114–15; controlling through facility centralization, 117; effect on archaeological practice, 115–17, 116; for long-term curation, 27, 92, 93, 95; range of in 1998, 115, 116
Curation of Federally-Owned and Administered Archeological Collections (36 CFR Part 79), 25, 42; on associated records management, 36–37; deaccessioning and, 39; on inventory/inspection of collection, 71; key components of, 26; lack of

certification language in, 41; repositories and, 27, 45, 80, 81; standards and, 30, 33, 35
curator, 20, 54, 55, 56
curiosity cabinet, 8

database, for electronic access, 104–6
Davis, E. H., 8
deaccessioning, 39–40, 72–73, 83
deed of gift, 60, 95, 122
Department of the Interior, 49, 71
destructive analysis, 101–2
digital publications, 76
disposal, of object, 72, 73
document/record: storing, 37, 70, 89; submitting with collection, 88–90, 96, 97, 99
Dunnell, Robert, 108–9

electronic management, of record/report, 37–38, 89, 90
ethics, in curating, 79–80
Europe, public museum development in, 8

facility report, 76
Farnsworth, Kenneth, 33
Field Museum of Natural History, 8, 10
field school, 10, 15
fieldwork: managing records/reports from, 79, 80, 87–90; project design concerns for, 80–83, 82; sampling/conservation after, 85–87, 88; sampling/conservation during, 83–85, 84
flotation technique, 19
Frank H. McClung Museum, 15–16, 124
funding, 43, 113–18, 123

Government Accounting Office (GAO), 25

government repository, 49–50
grants/funding, 43, 113–18, 123
Guthe, Carl E., 10

Harrington, M. R., 8
Heye Foundation. *See* Museum of
 the American Indian
historic preservation movement:
 effect on collections, 23; effect on
 curation prejudice, 12
Historic Sites Act of 1935, 12
Historic Sites Act of 1945, 18
historical society, as repository, 48
Holmes, William Henry, 8
Hrdlička, Aleš, 8
human remains, storage of, 69. *See
 also* Native American Graves
 Protection and Repatriation Act

Institute of Museum and Library
 Services, 114
Interagency Archeological Salvage
 Program, 18
Interagency Federal Collections
 Working Group, 43
Internet, accessing collection via,
 106–8, 107, 111
Internet site: archives/records
 management, 121; career
 information, 121; conservation,
 122; curation/conservation
 educational opportunities,
 122–23; deed of gift form, 122;
 digital archiving, 122; federal
 expertise at collections
 management, 123; grant/funding,
 123; gray literature/online
 publication, 123; historical
 preservation
 laws/regulations/standards,
 123–24; intellectual property,
 124; museum organization, 124;
 online collection/catalog, 121;
 online exhibit, 124–25; policy,

125; state curation guidelines,
 125
interpretation, definition of, 3
inventory control/data
 management, of collection, 71, 74

Jennings, Jesse, 13

Kneberg, Madeline, 14, 15, 16

labeling collections, 65–66
Lewis, Thomas M. N., 13, 15
Lipe, William, 108
loans, 75–76, 100–101
local historical museum, 93
looting/illicit trading of artifacts, 39

management/care, of collection:
 accessioning, 61–62; acquisition
 policy/practice, 60–61; cataloging,
 63–64; cultural resource
 management effect on, 20, 29;
 deaccessioning, 72–73; inventory
 control, 71; labeling/conservation,
 64–67; public access/use, 73–77;
 repository programs for, 51–52;
 standards for, 32–33; storage,
 67–71, 68
Mandatory Center of Expertise in
 Archaeological Curation and
 Collections Management, 42
Mason, Otis, 7–8
McKern, W. C., 11, 13
Midwestern Taxonomic Method, 11
Mills, William C., 8
Moorehead, Warren K., 8
Morgan, Lewis Henry, 5–6
Moss-Bennett Act. *See*
 Archeological and Historic
 Preservation Act (AHPA) of 1974
Moundbuilder Myth, 8
museum: definition of, 3–4, 46; as
 repository, 46–47, 51–52;
 university, 8, 9, 10

Museum of the American Indian, 7
Museum Services Act, 46

NABD-Reports, 44, 123
NADB. *See* National Archaeological
 Database
NAGPRA. *See* Native American
 Graves Protection and
 Repatriation Act
National Archaeological Database
 (NADB), 44, 106
National Endowment for the
 Humanities, 43, 114
National Environmental Policy Act
 of 1969, 18
National Historic Preservation Act
 of 1966, 27
national initiative for curation,
 need for, 41–42
National Institute for Conservation,
 114
National Museum of Natural
 History, 7, 105, 124
National Park Service (NPS), 12, 81;
 collection database of, 105;
 deaccessioning and, 39–40;
 repository of, 49; reservoir
 salvage and, 18
National Science Collections
 Alliance, 106
National Science Foundation, 43,
 114
Native American: curation issues
 concerning, 24, 38–39;
 involvement with repository,
 112, 113; museum/cultural
 center of, 48; ownership rights
 of, 31
Native American Graves Protection
 and Repatriation Act (NAGPRA),
 25–27, 30, 31, 40, 44, 69, 71, 101,
 108
Nelson, Nels C., 8
New Archaeology, 19

New Deal project, 11. *See also*
 Chickamauga Basin Project
New York State Museum, 9, 10
NPS. *See* National Park Service

on-site access, 100
ownership, of collection, 29–31, 71,
 95

Parker, Arthur C., 8, 9
Peabody Museum of Archaeology
 and Ethnography, 7, 8, 47, 54, 124
Peale's Museum, 6
permanent loan, 75
photograph/negative: access to, 76;
 storage of, 70, 89, 90
physical space, for collection, 74, 96
pottery typology, 11
professional responsibilities, in
 archaeological curation, 33–34,
 79–80
project design: collection strategy
 in, 79, 82; identifying repository
 in, 80–81, 91; modifications to,
 83
public works project, 11. *See also*
 Chickamauga Basin Project
Putnam, Frederick Ward, 8–9

R. S. Peabody Museum, 47
regional repository, 43
registrar, 54, 55, 59
registration methods, 59
repository: certification of, 40–41;
 definition of, 3, 4, 45; identifying
 in project design, 80–81, 91; for
 records/reports, 88–89; role in
 project design, 80–83. *See also*
 curation, long-term; repository,
 curatorial staff for; repository,
 type of; repository program
repository, curatorial staff for,
 53–54; typical curation-related
 jobs, 55

repository, type of: academic, 47–48; archives, 50; government, 49–50; historical society, 48; museum, 46–47; regional, 43; tribal museum/cultural center, 48. *See also* repository; repository, curatorial staff for; repository program

repository program: collections management, 51–52; educational program/exhibit, 52–53; research, 53. *See also* repository; repository, curatorial staff for; repository, type of

research design, 79. *See also* project design

Reservoir Salvage Act of 1960, 18

River Basin Salvage Program, 18

Rochester Museum, 9, 10

Sabloff, Jeremy, 8

Salwen, Bert, 108–9

sample, representative: encouraging repository to curate, 111–12; preserving, 108–11

sampling strategy, 109; during fieldwork, 83–84; in laboratory, 85–87

Smithson, James, 6

Smithsonian Institution, 6, 8, 18

Society for American Archaeology (SAA), 9, 34, 44, 108

Society for Historical Archaeology, 34, 44

Society of American Archivists, 56

Squier, E. G., 8

State Historic Preservation Office, 113

storage, of collection: basic standards for, 68; container for, 68–71; document/records, 37, 70, 89; environmental control, 67–68; human remains/sacred objects, 69; physical area for, 67; unacceptable container, 70

Struever, Stuart, 33

Systematic Anthropological Collections program, 43

technician, 55, 56–57

Tennessee Valley Authority (TVA), 13

Thomas, Cyrus, 8

Thomsen, J. C., 5

transfer of title, 60

Tribal Historic Preservation Office, 113

tribal museum/cultural center, as repository, 48

TVA. *See* Tennessee Valley Authority

type collection, 99

Webb, William, 13–14

Willey, Gordon, 8

Works Progress Administration (WPA), 13, 28. *See also* Chickamauga Project

world's fair, 6–7

ABOUT THE AUTHORS AND SERIES EDITORS

Lynne P. Sullivan is curator of archaeology at the Frank H. McClung Museum and research associate professor in the Department of Anthropology at the University of Tennessee. She has more than twenty years experience in making, researching, and curating archaeological collections in the southeastern, midwestern, and northeastern United States. Her main area of expertise is the late prehistory of the Southeast. Dr. Sullivan has worked for university research centers and state, local, and university museums, and she is a member of the Society for American Archaeology's Committee on Curation. She received her doctorate in anthropology from the University of Wisconsin–Milwaukee, where she also earned a certificate in museology.

Dr. Sullivan has published numerous books and articles on southeastern archaeology, the history of archaeology, and the curation of archaeological collections. These include *The Prehistory of the Chickamauga Basin in Tennessee* (University of Tennessee Press, 1995), the two-volume report of the University of Tennessee and Works Progress Administration's excavations before flooding of the Tennessee Valley Authority's Chickamauga Reservoir; and *Grit-Tempered: Early Women Archaeologists in the Southeastern United States* (University Press of Florida, 1999). Between 1987 and 1991, she directed major projects, funded by the National Science Foundation, to inventory, organize, and create a computer database for the archaeological collections at the New York State Museum. More recently, she has worked on "Archaeology of the Native Peoples of Tennessee," a major permanent exhibition at the McClung Museum. She currently is directing a project to create an online archive of pho-

tos from the WPA/TVA archaeological projects, funded by the Institute of Museum and Library Services, and serves as editor of *Southeastern Archaeology*.

S. Terry Childs is an archaeologist in the Archeology and Ethnography Program of the National Park Service in Washington, D.C. She is actively involved in federal archaeological curation efforts for objects, records, and reports (e.g., gray literature), including policy formulation. As the coordinator of several national level databases, including the National Archeological Database, she is also concerned about the proper management and curation of archaeological digital data. In her role as leader of the NPS Cultural Resources Web team, Dr. Childs has been instrumental in using the World Wide Web to highlight museum collections and issues related to their management. She just launched a self-motivated course on the Web, called "Managing Archeological Collections: An Online Course" (www.cr.nps.gov/aad/collections), which is designed to complement this book. She was recently appointed chair of the new Committee on Curation by the Society for American Archaeology.

Dr. Childs received her doctorate in anthropology from Boston University in 1986. Her primary field research interest is the Iron Age of Sub-Saharan Africa, particularly involving the anthropology of technology. She has worked in Tanzania, the Democratic Republic of the Congo, Zimbabwe, and Uganda and has published extensively on this work. Her research on collections from Africa and northeastern United States is conducted as a research collaborator with the Smithsonian Institution and a Research Associate with the R. S. Peabody Museum in Andover, Massachusetts.

Larry J. Zimmerman is the head of the Archaeology Department of the Minnesota Historical Society. He served as an adjunct professor of anthropology and visiting professor of American Indian and Native Studies at the University of Iowa from 1996 to 2002 and as chair of the American Indian and Native Studies Program from 1998 to 2001. He earned his Ph.D. in anthropology at the University of Kansas in 1976. Teaching at the University of South Dakota for twenty-two years, he left there in 1996 as Distinguished Regents Professor of Anthropology.

While in South Dakota, he developed a major CRM program and the University of South Dakota Archaeology Laboratory, where he is still a research associate. He was named the University of South Dakota Student Association Teacher of the Year in 1980, given the Burlington Northern Foundation Faculty Achievement Award for Outstanding Teaching in 1986, and granted the Burlington Northern Faculty Achievement Award for Research in 1990. He was selected by Sigma Xi, the Scientific Research Society, as a national lecturer from 1991 to 1993, and he served as executive secretary of the World Archaeological Congress from 1990 to 1994. He has published more than three hundred articles, CRM reports, and reviews and is the author, editor, or coeditor of fifteen books, including *Native North America* (with Brian Molyneaux, University of Oklahoma Press, 2000) and *Indians and Anthropologists: Vine Deloria, Jr., and the Critique of Anthropology* (with Tom Biolsi, University of Arizona Press, 1997). He has served as the editor of *Plains Anthropologist* and the *World Archaeological Bulletin* and as the associate editor of *American Antiquity*. He has done archaeology in the Great Plains of the United States and in Mexico, England, Venezuela, and Australia. He has also worked closely with a wide range of American Indian nations and groups.

William Green is director of the Logan Museum of Anthropology and adjunct professor of anthropology at Beloit College, Beloit, Wisconsin. He has been active in archaeology since 1970. Having grown up on the south side of Chicago, he attributes his interest in archaeology and anthropology to the allure of the exotic (i.e., rural) and a driving urge to learn the unwritten past, abetted by the opportunities available at the city's museums and universities. His first field work was on the Mississippi River bluffs in western Illinois. Although he also worked in Israel and England, he returned to Illinois for several years of survey and excavation. His interests in settlement patterns, ceramics, and archaeobotany developed there. He received his master's degree from the University of Wisconsin–Madison and then served as Wisconsin SHPO staff archaeologist for eight years. After obtaining his Ph.D. from the University of Wisconsin–Madison in 1987, he served as state archaeologist of Iowa from 1988 to 2001, directing statewide research and service programs including burial site protection, geographic information, publications, contract services,

public outreach, and curation. His main research interests focus on the development and spread of native agriculture. He has served as editor of the *Midcontinental Journal of Archaeology* and *The Wisconsin Archeologist*; has published articles in *American Antiquity*, *Journal of Archaeological Research*, and other journals; and has received grants and contracts from the National Science Foundation, National Park Service, Iowa Humanities Board, and many other agencies and organizations.